VINCENT VAN GOGH

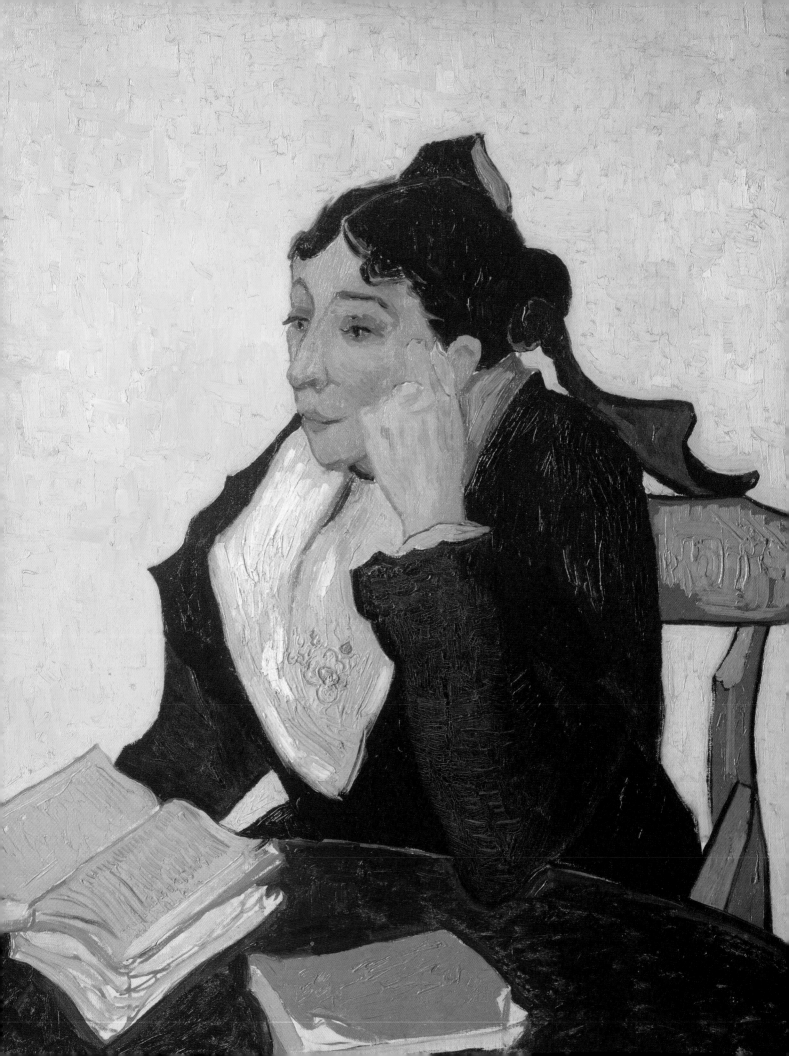

VINCENT VAN GOGH

ART MASTER

SUSIE HODGE

ARCTURUS

ARCTURUS

This edition published in 2023 by Arcturus Publishing Limited
26/27 Bickels Yard, 151–153 Bermondsey Street,
London SE1 3HA

Copyright © Arcturus Holdings Limited

ISBN: 978-1-78828-578-0
AD006173UK

Printed in China

CONTENTS

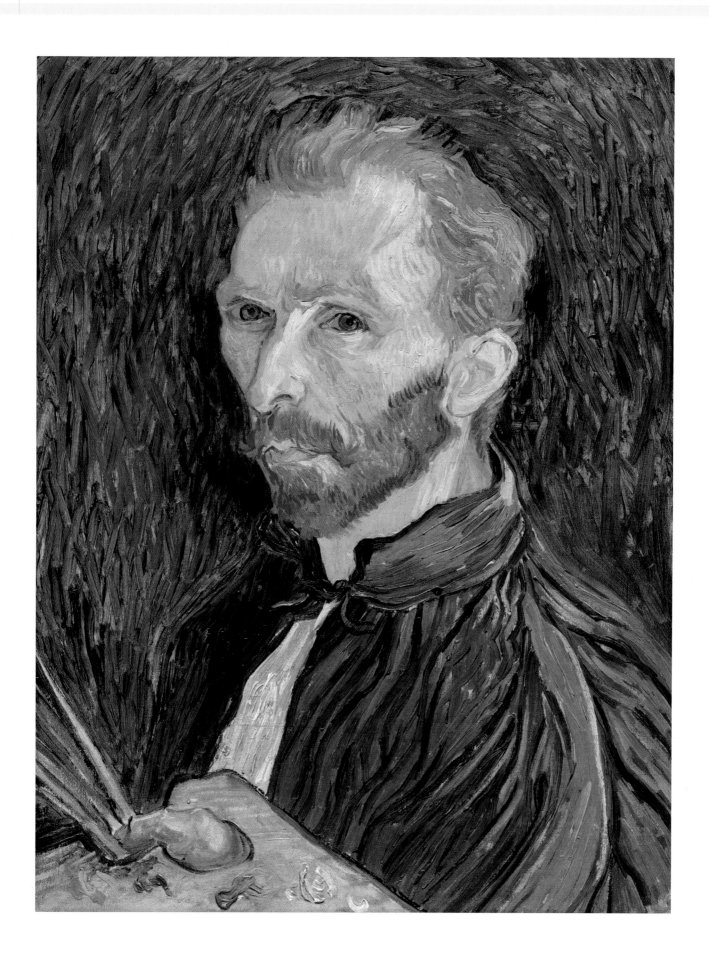

INTRODUCTION

One of the most legendary artists in history, Vincent van Gogh (1853–90) has been the subject of many books, films and songs – yet he did not achieve fame until after his death and his troubled and tragic life was spent in poverty. While he is now admired the world over for his colourful, expressive paintings and emotive drawings that paved the way for Expressionism, Fauvism and other modern art movements, he made art that was at variance with the accepted artistic approach of his times. Most of his work was produced over just ten years, while he was struggling with both physical and mental illnesses, and when he died at just 37, he left a remarkable legacy of approximately 2,000 works of art and hundreds of letters that reveal his extraordinary thought processes and vision.

After trying several different careers for which he proved unsuitable, Vincent decided to become an artist – a choice that was only made possible by the emotional and financial support provided by his brother Theo. With an earthy palette and strong chiaroscuro (dramatic contrasts of tone), his earliest art followed the Dutch tradition before he joined Theo in Paris and learned from the avant-garde artists of the day. As soon as he reached Arles in the south of France, his genius emerged. He knew that he was exploring a completely new way to use dazzling colours and thick, expressive brushstrokes to convey emotion, and despite it not being appreciated, he continued in his own style, painting landscapes, night scenes, peasants at work, sunflowers and self-portraits. His bold experimentation was unprecedented and produced at huge risk to his health and sanity, but the intense emotions he experienced in his life can be seen in every work of art that he created.

This book is part of a series introducing great artists who changed the course of art. It charts Vincent's journey as an artist, exploring the places he lived, his often fraught relationships, how his individual style evolved, and the artistic influences that contributed to his extraordinary legacy.

Self-Portrait, 1889. Vincent's painting style of thick impasto paint, obvious outlines and expressive colours contradicted accepted styles of his time. Through his portrayal of emotion using all these elements, he changed the course of art.

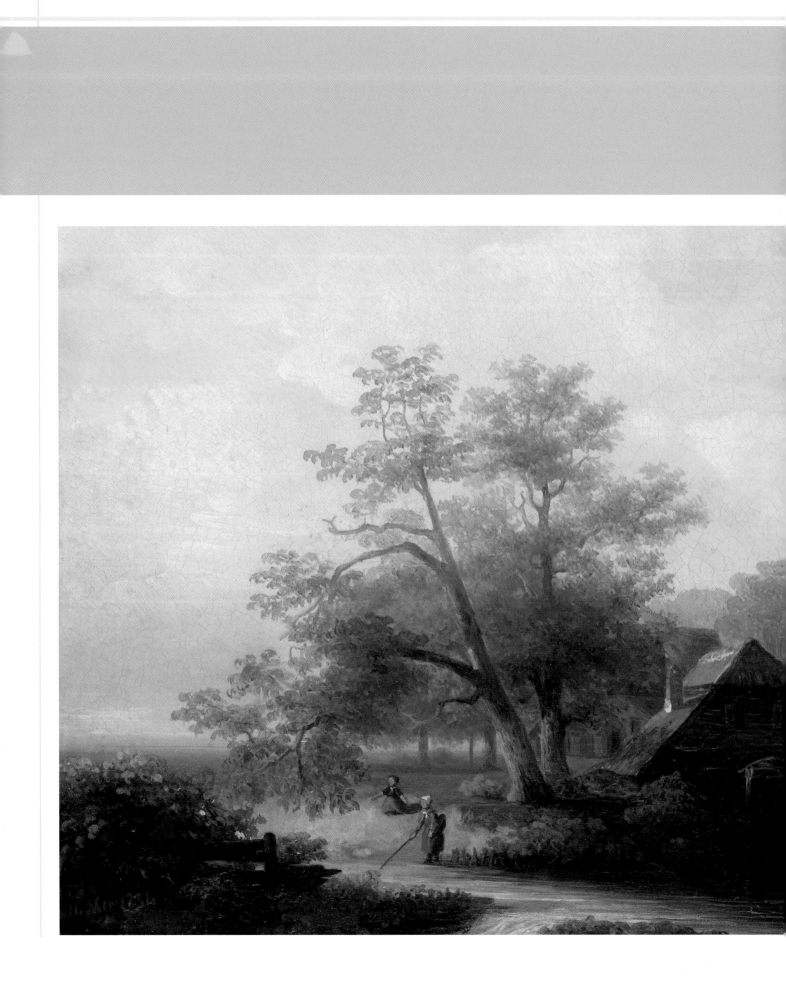

CHAPTER 1
Early Life

On 30 March 1852, Anna Cornelia van Gogh, wife of the Reverend Theodorus van Gogh, gave birth to a stillborn son whom the couple named Vincent Willem. Exactly one year later, on 30 March 1853, they had another baby boy, this time strong and healthy, to whom they gave the same name. Vincent was followed by five siblings: Anna, Theodorus, or Theo, Elisabeth, or Lies, Wilhelmina, or Wil and Cornelius, or Cor.

The family lived in the Dutch village of Groot Zundert in North Brabant, close to the Belgian border. Theodorus was a pastor in the Dutch Reformed Church, and Vincent grew up in a devout household; his parents were quiet, modest people who regularly moved from one small parish to another. Vincent and Theo shared a bedroom in Groot Zundert and became especially close.

At the age of 11, Vincent was moved from the local village school to a boarding school in the town of Zevenbergen, 25 km (15½ miles) north of Groot Zundert. Although unhappy there, he stayed for two years until he was transferred to another boarding school in Tilburg, approximately 45 km (28 miles) from Zundert. Little is known about his education except that he was good at languages and became proficient in English, French and German; that drawing was a large part of the curriculum; and that he left his last school halfway through his second academic year when he was 15, although it is not clear why.

A Watermill in a Woody Landscape, *Lodewijk Hendrik Arends, 1854. Landscape painting became a popular genre in Dutch art during the sixteenth century, and paintings of the Dutch landscape remained sought after in the nineteenth century. The young Vincent grew up extremely aware of the national tradition.*

FIRST JOB

Vincent's Uncle 'Cent' (also Vincent van Gogh) had recently retired from his job as an art dealer, and he found the 16-year-old Vincent a position as a trainee at the international gallery Goupil & Cie. With headquarters in Paris and branches in London, Brussels, The Hague, Berlin and Vienna, Goupil & Cie specialized in French contemporary art. Vincent began working in The Hague branch. His boss recounted that he began 'eager and ambitious' and with 'a friendly manner towards everyone'. In the summer of 1872, he went home to Helvoirt, where his father had been given a new parish. Theo joined them from school and during that holiday, the two brothers agreed to support each other and correspond regularly. This correspondence continued for the rest of Vincent's life, except for a short time when they lived together in Paris. The following September, Theo left school and also began working as an art dealer at Goupil & Cie's branch in Brussels. Meanwhile, Vincent was transferred to the London branch.

Flower Beds in Holland, c.1883. *Vincent made this painting when he returned to live in The Hague a few years later. From a low viewpoint, he uses linear and aerial perspective to draw the viewer's eye into the scene. The colourful tulips in the foreground contrast with the dark thatched cottages and bare tree trunks in the distance.*

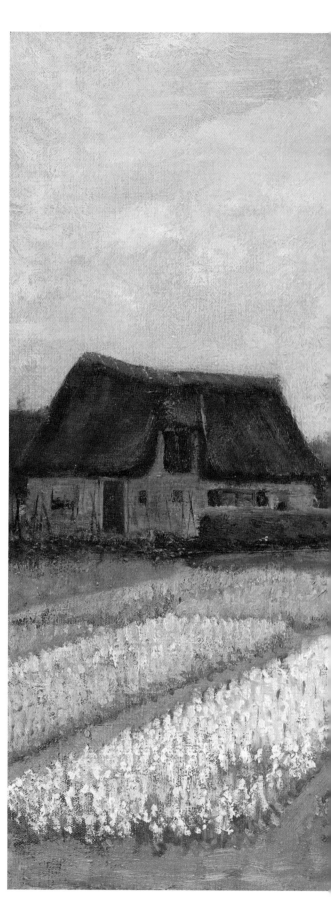

Portrait of Theo van Gogh, 1887. *This small work was long thought to be a self-portrait, but after much research it is now believed to be of Theo, and possibly the only portrait of his brother that Vincent ever made.*

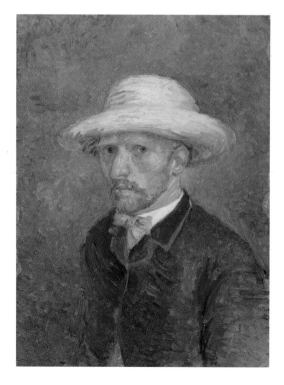

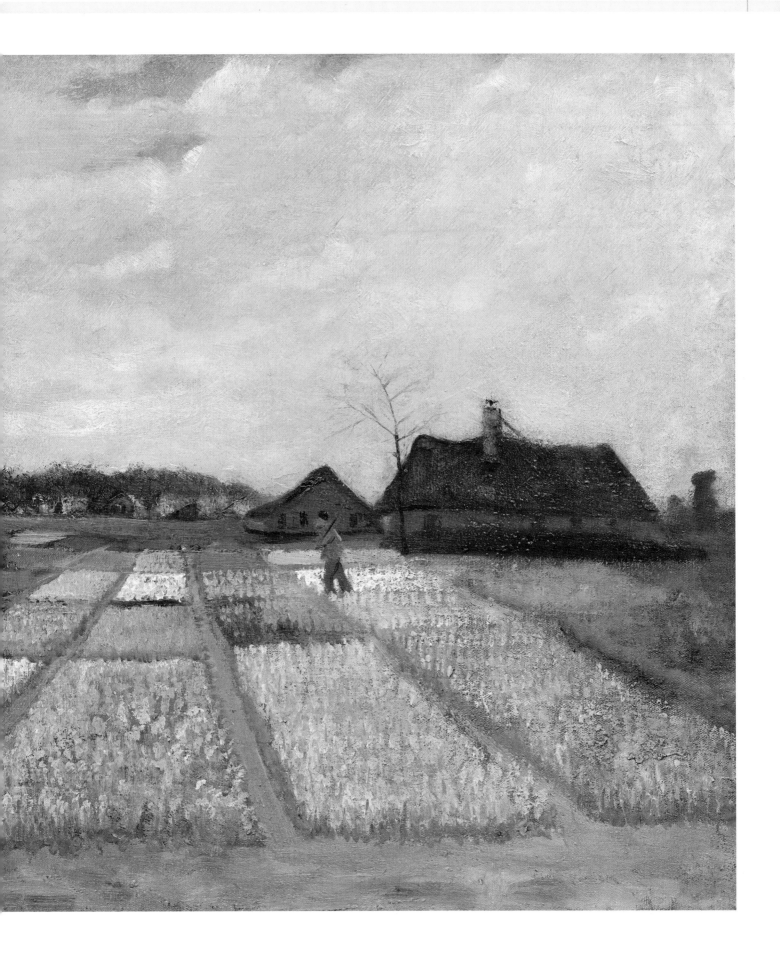

THE LETTERS

Almost 1,000 letters survive from Vincent's life, written by, to or about him. Although he did not keep many that he received, there are more than 650 in existence that he wrote to Theo. Others survive, such as several he wrote to his sister Wil and other relatives, and to his artist friends including Paul Gauguin, Émile Bernard, Eugène Boch and Anthon van Rappard. When he died, a letter he was writing to Theo was discovered unfinished in his pocket.

The letters reveal much about Vincent's ideas, working processes and the evolution of his art. They are a record of a passionate and intense man who often felt isolated and lonely, and it is largely through these letters, first published in 1914, that we know how much Theo did for Vincent, and how much gratitude and guilt Vincent sometimes felt about it. In one letter he wrote: 'I will give you back the money or give away my soul.' In another: 'I have to thank you for quite a few things, first of all your letter and the 50-franc note it contained, but then also for the consignment of colours and canvas that I've been to collect at the station.'

Vincent poured out all his thoughts in his letters, from the small details of everyday life to his more profound beliefs about existence, his psychological difficulties and his vivid imagination. He described his feelings as well as events that happened to him, his views on colour theory and contemporary literature he

In this letter to Theo from Drenthe, dated 28 October 1883, Vincent wrote of his thoughts and visions, adding this sensitive drawing of a man pulling a harrow. Even in their rough note form, his images are uniquely dynamic and expressive.

An excerpt from one of Vincent's letters to Theo from April 1885 in which he described and made a sketch of his painting The Potato Eaters, *which he was working on at the time. He wrote,* 'I've painted it on a fairly large canvas, and as the sketch is now, I believe there's life in it.'

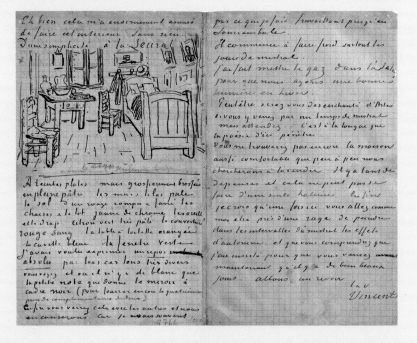

was reading. Frequently illustrated, his letters also show how he planned his paintings. In words and drawings, he described people, places, colours, and his anxieties and preoccupations about his art. The letters are a record of his great struggle; his knowledge that he was trying to do something special and extraordinary, while also being full of self-doubt and lacking self-esteem. Yet despite all his insecurities and health problems, he was firm about his art, for instance: 'I want you to understand clearly my conception of art … What I want and aim at is confoundedly difficult, and yet I do not think I aim too high. I want to do drawings which touch some people.'

While waiting for Gauguin's visit to Arles, Vincent wrote to him on 17 October 1888, explaining that on his journey from Pont-Aven to Arles, he would see 'miles and miles of countryside of different kinds with autumn splendours'. *He also made a sketch of his painting* The Bedroom.

VINCENT IN LONDON

During his time in London, Vincent walked in the parks, rowed on the River Thames and visited the British Museum and the National Gallery. At the Royal Academy Summer Exhibition he admired paintings by J.M.W Turner, John Constable, John Everett Millais, Luke Fildes, Frank Holl and Hubert von Herkomer. He also began improving his English by reading a range of British writers, including William Shakespeare, John Keats, Charles Dickens and Christina Rossetti. He wrote to friends: 'These last days I have greatly enjoyed reading the poems of John Keats; he is a poet who, I think, is not very well known in Holland. He is the favourite of all the painters here.' To Theo, he wrote: 'I'm getting on very well here. I've got a

on very well here. I've got a delightful home and I'm finding it very pleasurable taking a look at London and the English way of life and the English people themselves.' He also admired British graphic illustrations and prints, especially those by artists such as Fildes, Holl, Herkomer and Millais who illustrated the English magazine *The Graphic* (founded in 1869), writing to Theo: 'For me one of the highest and noblest expressions of art is always that of the English, for instance Millais and Herkomer and Frank Holl. What I mean in regard to the difference between the old masters and the modern ones is – perhaps the modern ones are deeper thinkers.' He and Theo collected classic Dutch prints and English prints from popular magazines including *The Graphic* and the *Illustrated London News*, founded in 1842.

In 1872, *London: a Pilgrimage* was published, written by William Blanchard Jerrold and illustrated by Gustave Doré. The book had taken four years to complete and the two men had spent days and nights exploring the streets of London in their mission to produce an illustrated record of the 'shadows and sunlight' of the city. Using strong effects of light and shade, Doré's 180 engravings in the book capture the atmosphere, places and most of all the people of London at the time. Vincent was fascinated by it.

Study for Deserted – a Foundling, *Frank Holl, 1874. Holl made an engraving of this scene for* The Graphic. *Vincent collected some of Holl's engravings and wrote in 1883: 'When I was looking them over, all my memories of London … moved me so deeply that I have been thinking about them ever since, for instance Holl's* The Foundling.'

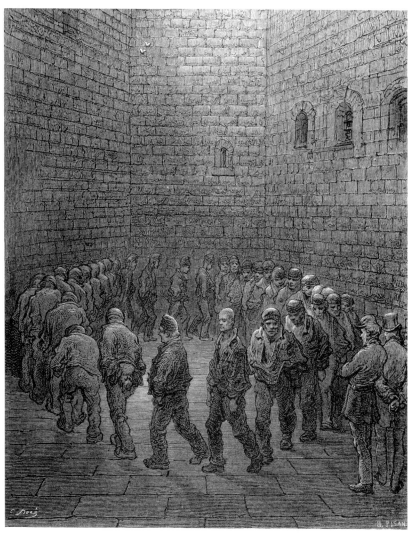

Prisoners in Newgate Prison Exercise Yard, *Gustave Doré, 1869–72. Doré's powerful engravings of London were widely praised. In later life, Vincent returned to them, painting his only image of London,* Prisoners Exercising, *from this print by Doré of Newgate Prison.*

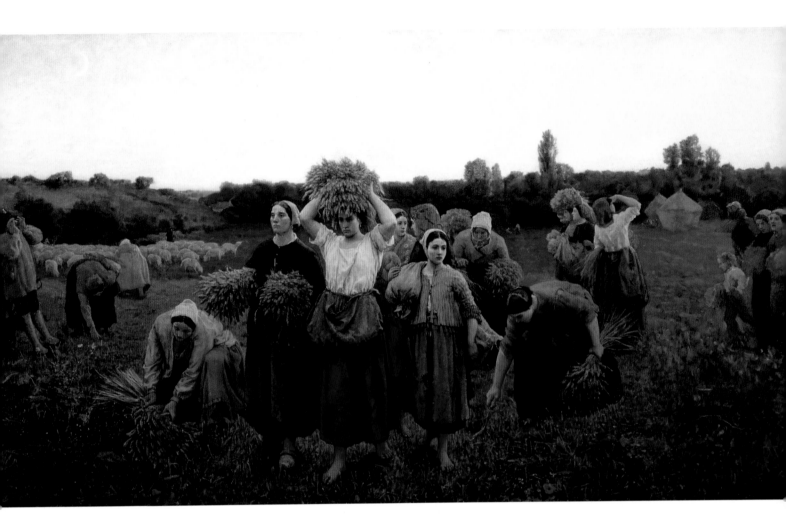

LOVE REJECTED

A few months after arriving in London, Vincent moved into a boarding house run by a widow, Sarah Ursula Loyer, who also ran a boys' school. He wrote to Theo about how much he enjoyed the bustle of the household and tending the garden. In July 1874, his sister Anna arrived and stayed there with him. Vincent had fallen in love with Ursula's daughter, Eugenie, even though she was already engaged to someone else; nonetheless, Vincent proposed to her and refused to accept her rejection, so Ursula asked him to leave. He and Anna moved to another boarding house, but he became melancholy and withdrawn and began acting strangely, which worried Anna. He remained friends with the Loyers, but later wrote that the rejection of his love caused him 'many years of humiliation'. After he had spent the summer of 1874 back at home in the Netherlands, their mother wrote to Theo about him: 'Poor boy, he does not take life easily.'

DISCOVERING PARIS

In May 1875, Vincent was transferred to Goupil & Cie in Paris. Once there he became increasingly religious and his letters to Theo were full of quotations from the Bible and accounts of church services and sermons he attended. He also regularly visited the Musée du Louvre and the Musée du Luxembourg, becoming uplifted by the paintings of artists including Rembrandt and Charles-François Daubigny. He later wrote to Theo: 'Rembrandt goes so deep into the mysterious that he says things for which there are no words.' He also visited an exhibition of work by Jean-Baptiste-Camille Corot, the annual Salon, where he especially admired a painting by Jules Breton, and a sale of drawings by Jean-François Millet, writing to Theo: 'There has been a sale here of drawings by Millet. When I entered the hall of the Hôtel Drouot where they were exhibited, I felt like saying, "Take off your shoes, for the place where you are standing is Holy Ground."'

Calling in the Gleaners, *Jules Breton, 1859. After moving to Paris in 1875, Vincent visited the Musée du Luxembourg every week, sometimes with Harry Gladwell. This was one of several paintings in the museum that Vincent particularly admired. Breton's paintings appealed to Vincent as he depicted peasants conducting their harsh lives with dignity. This particularly inspired him for its frieze-like composition and rich colouring.*

The Church at Gréville, *Jean-François Millet, c.1871–4. This painting by Millet was another of Vincent's favourites at the Musée du Luxembourg and he retained the composition in his memory. Later, he painted several versions of the church at Nuenen and then his more famous* Church at Auvers, *using compositions influenced by Millet's* Church at Gréville.

Vincent shared his lodgings in Montmartre with another Goupil & Cie employee, an Englishman named Harry Gladwell, whom he had met in England and whose father owned an art gallery in London. Each evening, Vincent and Harry sat together, reading and discussing the texts of Dickens, George Eliot and, most of all, the Bible. He lived an abstemious life and despite his enjoyment of church-going and art-viewing, he became depressed and his enthusiasm for his job waned. In December, he left Paris and returned home to Etten to spend Christmas with his family, even though he had not been given leave to go and it was Goupil & Cie's busiest time of year. On his return early in 1876, he was dismissed.

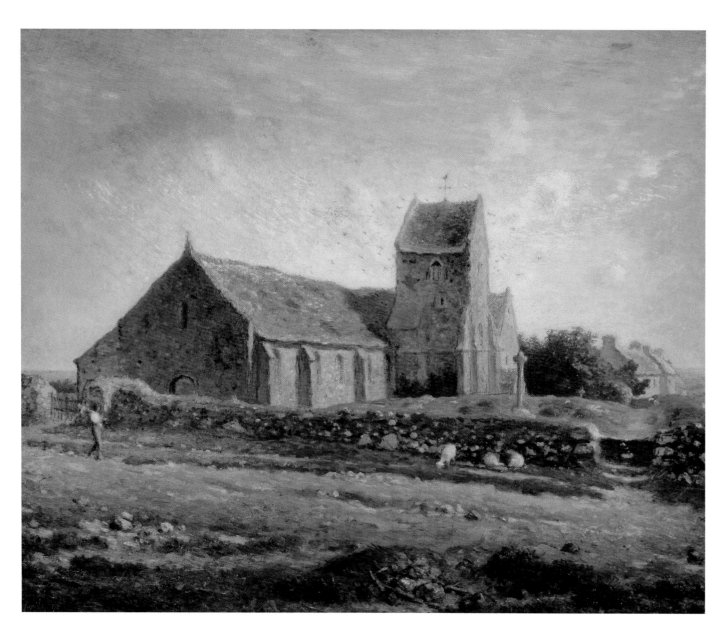

ENGLAND AND AMSTERDAM

Vincent applied for several jobs in England and received a letter from one William Port Stokes, proprietor of a boys' boarding school in Ramsgate, offering him a position as an assistant teacher. He would receive board and lodging, but no salary. He accepted, but he had been there for only two months when Mr Stokes relocated the school from Ramsgate to Isleworth, near London. Vincent moved with the school, but within a few days he met the Reverend Thomas Slade-Jones, who ran a private Methodist boys' boarding school and invited Vincent to work for him as an assistant teacher. Part of his job was to visit sick pupils and parents who had fallen behind with their school fees, many of whom lived in poverty; this aroused his ready compassion and led to a new desire to become a missionary.

In December, Vincent left Isleworth for Etten, to spend Christmas with his parents. Concerned that he seemed low and anxious, Theodorus persuaded him not to return to

Still Life with Bible, 1885. Seven years after leaving Amsterdam, Vincent painted his father's Bible with his own copy of La Joie de Vivre *by Émile Zola and a candle. It was a modern memento mori ('remember you will die'), symbolizing the brevity of life.*

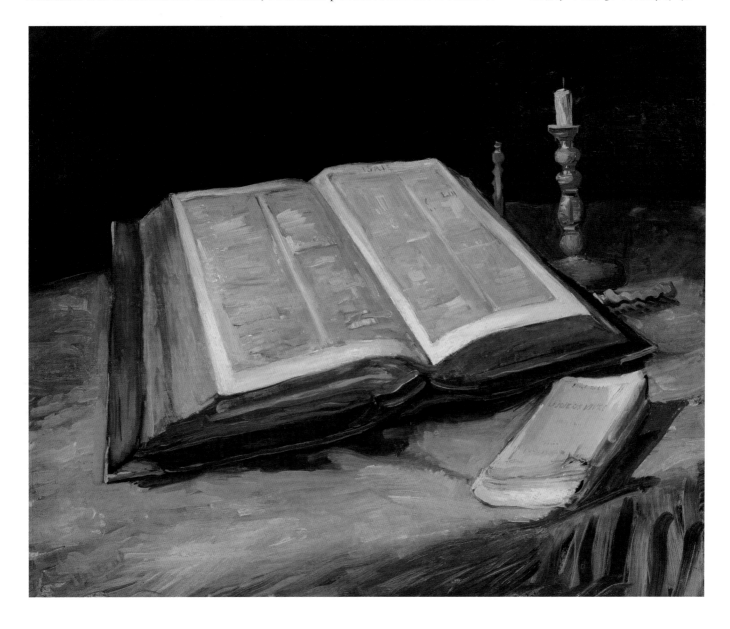

England. Once again Uncle Cent found him a job, this time in a bookshop in Dordrecht, near Rotterdam. However, his religious fervour was increasing. He translated the Bible from Dutch into French, German and English and attended daily religious services. He also began to draw quite fervently, on paper and on the walls of his rented room. After just four months, he returned home and persuaded his parents to agree to his plan of studying theology. In May 1877, he travelled to Amsterdam to prepare for entrance exams for Amsterdam University. Several family members lived in the city, including Uncle Johannes Paulus Stricker, who was a church minister and married to one of Vincent's aunts, and his Uncle 'Cor' (Cornelius Marinus van Gogh), a bookseller whom Vincent visited often. He lived with his 'Uncle Jan', Johannes van Gogh, a widower and the director of Amsterdam's naval dockyard who lived in a large house overlooking the docks, and every day he walked to the house of Maurits Benjamin Mendès da Costa, who taught him algebra, geometry and the histories of Greece, Asia Minor and Italy in preparation for the entrance exams. Nevertheless, he struggled and when he sat the exams after 15 months, he failed. Although he had enjoyed living in Amsterdam, including visiting the newly opened Rijksmuseum, he returned home to his parents in July 1878.

The Harvest, *Charles-François Daubigny, 1851. This large, light painting uses colours that anticipate the work of the Impressionists. It was a great success at the 1852 Paris Salon. Over the following years, Daubigny's innovations, including painting in light colours in the open air and capturing transient effects, inspired a number of younger artists, including Vincent.*

'CHRIST OF THE COAL MINE'

Still determined to follow his beliefs, Vincent went to Brussels with his father and the Reverend Slade-Jones from England, and in August 1878 he began a three-month course at a seminary for lay preachers. At the end of the course he was not accepted for the next stage of training but was allowed to go as an independent missionary to the Borinage coal-mining region in southern Belgium.

Early in December, he arrived at the village of Pâturage in the Borinage, where he stayed for several weeks before moving to nearby Wasmes for his trial period as a preacher. Shocked by the poverty around him, he wrote to Theo: 'It's a sombre place, and at first sight everything around it has something dismal and deathly about it. The workers … are … emaciated and pale owing to fever … exhausted and haggard, weather-beaten and prematurely old, the women generally sallow and withered.'

In mid-January 1879, he began a temporary position as a preacher, and became completely taken up by his longing to help all those he encountered. He left his lodgings with the local baker and his family, and moved into an outhouse where he slept on a straw mattress on the floor; he nursed the sick, including during an epidemic of typhus; he went down into the most dangerous mines to preach; gave away his clothes, food and money to the poorest around him; and he stopped washing the coal dust from his face. He ate little, and became weak and thin. When the baker's wife asked him why he was doing this, he told her, 'I am a friend of the poor like Jesus was.' The local population decided he was mad and nicknamed him 'Christ of the Coal Mine'. After his six-month trial period, his contract was not renewed.

Miners' Wives Carrying Sacks of Coal, 1882. The acuity of Vincent's observations of, and sympathies with, the people around him soon began to appear in his drawings and paintings. Painted two years after he left the Borinage district, this shows women carrying heavy sacks. Their positions, captured with just a few lines, convey the repetition and arduousness of their work.

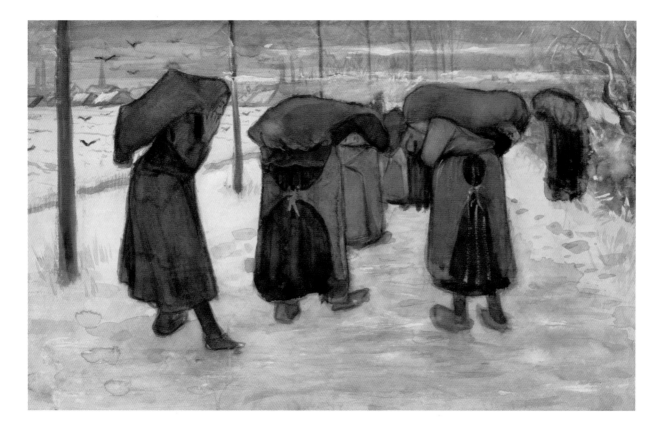

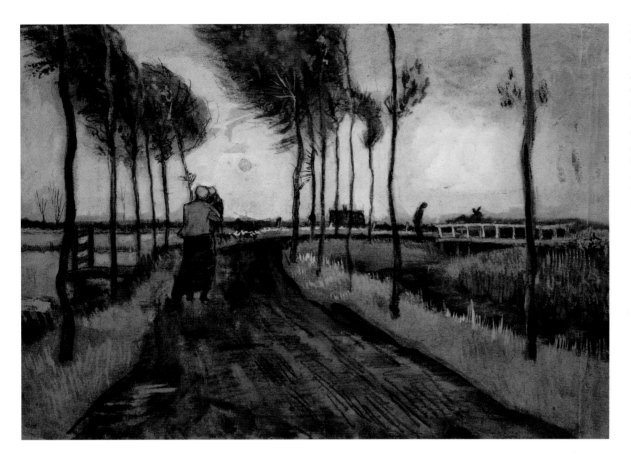

Landscape with Woman and Child, *1883. The plight of the poor aroused Vincent's compassion and empathy. In this drawing the low sun shrouded in mist and the trees bending in the wind convey the bleakness of the landscape.*

A MAN OF PASSIONS

The following month, in August 1879, Vincent stayed in the village of Cuesmes in the Borinage. With no backing from the Church, he continued preaching to the poor, but his impassioned speeches and extreme behaviour frightened the people he was trying to help. Although his father and Theo sent him money, he was so poor that he barely ate. In October, Theo visited and tried to persuade him to leave and plan for the future, which enraged Vincent. After Theo left, no correspondence passed between him and the rest of his family for nine months. The family worried about his odd behaviour and Theodorus even began to consider having him committed to a psychiatric institution.

The winter of 1879–80 was a desperate time for Vincent. Lonely, starving and depressed, he drew profusely, and in March 1880, he walked nearly 80 km (50 miles) to the village of Courrières to meet the artist Jules Breton, who he hoped might give him some work or advise him. The walk took almost a week, but when he arrived in Courrières shyness overcame him and he turned back without even trying to meet Breton, surviving on the return journey by trading drawings for food and a night in a bed. In July 1880, he wrote to Theo, an extremely long letter that began: 'It is with some reluctance that I write to you, not having done so for so long … Up to a certain point you've become a stranger to me, and I too am one to you.' He continued: 'I, for one, am a man of passions, capable of and liable to do rather foolish things for which I sometimes feel rather sorry. I do often find myself speaking or acting somewhat too quickly when it would be better to wait more patiently … it's a matter of trying by every means to turn even these passions to good account.'

Shortly afterwards, he wrote to Theo again: 'I felt my energy revive, and said to myself, in spite of everything I shall rise again: I will take up my pencil, which I have forsaken in my great discouragement, and I will go on with my drawing. From that moment everything has seemed transformed for me.' Relieved that his troubled brother was moving away from the religious zeal that had overtaken him, Theo sent Vincent prints of several artists' works, and at the age of 27, Vincent decided to become an artist. That October, he left Cuesmes for Brussels, where he enrolled at the Academy of Art to learn about anatomy and perspective.

CHAPTER 2
Becoming an Artist

In November 1880, Vincent met fellow Dutch artists including Willem Roelofs and Anthon van Rappard. They became good friends, sharing their ideas about art, and Vincent worked in van Rappard's studio for a few months in the spring of 1881. Then in April, he travelled to his parents' home in Etten. He kept in touch with van Rappard for some while, but they fell out after van Rappard criticized Vincent's lithograph of his painting *The Potato Eaters* in 1885.

In order to earn money, Vincent determined to learn as much about art as possible. He considered becoming an illustrator for books and newspapers but then abandoned the idea. Meanwhile, Theo had been promoted to manager of Goupil & Cie's Parisian branch, and he was able to support Vincent financially so that he could focus on his art.

FAMILY ESTRANGEMENT

During the summer of 1881, Vincent's cousin, Cornelia 'Kee' Adriana Vos-Stricker, recent widow of a pastor and the mother of a four-year-old son, visited her aunt and uncle, Vincent's parents. Vincent fell in love with her, but she rejected him. As with Eugenie Loyer, Vincent continued making unwanted advances towards her so she cut her visit short and hurried back to Amsterdam. Still convinced that he could persuade her to change her mind, he followed her to propose marriage. He later wrote about what followed. When he arrived at his aunt and uncle's house, they refused to allow him to see Kee, so Vincent held his hand over a candle flame and said: 'Let me see her for as long as I can keep my hand in the flame.' Instead, his uncle blew out the flame and sent Vincent away.

When his own parents showed their concern about Vincent's behaviour over this, he quarrelled with them. On Christmas Day, he refused to go to church and there was a violent row. All his pent-up feelings emerged and he ranted and cursed. Theodorus told him to leave, and as he did, he heard the door being locked behind him. He later recalled that moment: 'It is and remains a wound which I carry with me.' Months later, he wrote: 'It lies deep and cannot be healed. After years it will be the same as the first day.' He travelled to The Hague where he found cheap lodgings on the outskirts of the city.

Road in Etten, 1881. While Vincent was living in Etten during 1881, he made numerous drawings of local peasants and labourers as they went about their daily business. From the start, he drew and painted with a sense of urgency.

REALISM

Largely recognized as the first modern art movement, Realism developed after the 1848 French Revolution, when some artists and writers rejected traditional forms of art and literature. The artists chose to paint the world as they saw it, abandoning the idealism that had been insisted upon for so long by established art academies.

The term 'Realism' was coined by the French novelist Champfleury, initially to describe the work of his friend Gustave Courbet. Realists were influenced by the naturalism of seventeenth-century Dutch artists, the more recent Dutch and English landscapists, and newly invented photography and portable oil paints. They reacted against what many

of them perceived as the excesses and self-indulgence of Neoclassicism and Romanticism, and they painted objectively, often depicting ordinary working-class people or direct images of nature. As well as Courbet, other Realists include Jean-Baptiste-Camille Corot, Édouard Manet, Rosa Bonheur, Jules Bastien-Lepage, Honoré Daumier and Millet.

Of all the artists whom Vincent admired, Millet possibly exerted the greatest influence on him. A painter and etcher

The Gleaners, *Jean-François Millet, 1857. Peasant life was Millet's primary theme and this painting evolved from ten years of observation. Millet's painting style fascinated Vincent, including the sense of volume, curving shapes, directional marks and the conveyed dignity of the poor.*

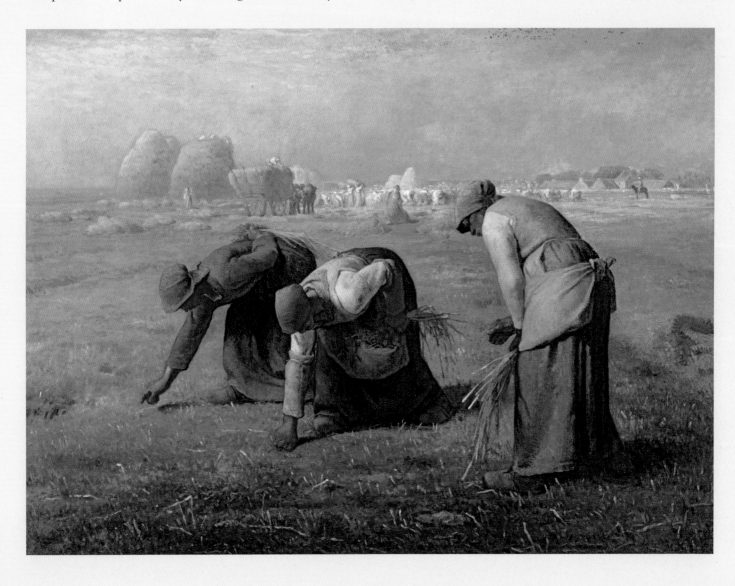

Old Man at the Fireside, *1881. Even this early in his career as an artist, Vincent demonstrates his sensitivity and ability to create atmosphere with varying contrasts of tones and thicknesses of lines, recalling Doré's engravings.*

of the Barbizon School, he produced about 700 paintings and 3,000 pastels and drawings over his career. He too felt great compassion for the poor, but unlike Vincent, he achieved success through his art during his lifetime, becoming renowned as the 'peasant-painter'. Vincent's description of him was, 'Millet is father Millet … counsellor and mentor in everything for young artists.' He bought etched reproductions of Millet's works from the art dealer Paul Durand-Ruel and began making copies of Millet's work.

As part of the Realist movement, from c.1830 to 1870, several painters settled in or near the French village of Barbizon by the Forest of Fontainebleau. There they painted the landscape, trees and people around them, often *en plein air* (in the open air) in a loose manner. Among them were Corot, Millet, Daubigny, Théodore Rousseau, Jules Dupré and Narcisse Virgilio Diaz de la Peña.

Influenced by the Barbizon School, the artists of the Hague School, which included Anton Mauve, Willem Roelofs and Jozef Israëls, lived and worked in The Hague. Like other Realists, they looked to the Dutch Golden Age of the seventeenth century as a source of inspiration and painted with subdued colours and loose brushstrokes, creating objective depictions of 'ordinary' people and the landscape.

THE HAGUE

While living in The Hague, Vincent took painting tuition from a cousin by marriage, Anton Mauve, who was a leading member of the Hague School of painters. After having a couple of lessons with Mauve in the summer of 1881, Vincent began attending his studio every day from late November. Art instruction generally focused on the study and practice of drawing for months before students began to paint, but from early on, Mauve taught Vincent the basics of watercolour and oil technique. Also unusually for art teaching of the time, he encouraged Vincent to paint an original still life rather than copy another artist's painting to begin with. Mauve also brought in models, helped Vincent to draw figures from life and was generally encouraging, even lending him money to rent and furnish a studio.

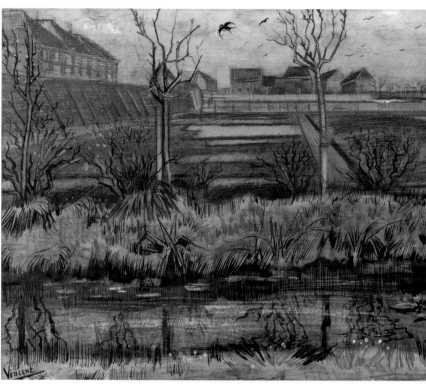

George Hendrik Breitner, another member of the Hague School at the time, met Vincent in the early months of 1882, and they often went on sketching trips together in the working-class districts of The Hague. However, it was a difficult friendship and Breitner later complained that while he discreetly drew in a small sketchbook, Vincent usually turned up with a lot of equipment, which unnerved the people they were attempting to draw. Vincent was drawing frenziedly all the time and his Uncle Cor gave him his first commission; a series of drawings of views of The Hague. He emulated Millet's style, and to a slightly lesser extent artists of the Hague School, including Mauve and Israëls; influences from Daumier, Rembrandt, Peter Paul Rubens, Johannes Vermeer and Félix Ziem can also be seen.

Fishing Boat on the Beach, *Anton Mauve, 1882. In a letter to Theo, Vincent called this painting 'a masterpiece'. Mauve was one of several early influences on Vincent.*

Still Life with Cabbage and Clogs, *1881. Vincent wrote to Theo: 'Mauve immediately installed me in front of a still life consisting of a couple of old clogs and other objects.' It was rare for a student artist to be allowed to paint with oils so early, and although Vincent's later characteristic style is not yet apparent, this work reveals his great promise.*

Nursery on the Schenkweg, 1882. *This depiction of a flower nursery is one of the drawings Vincent sent to his uncle in May 1882. It shows Vincent's use of perspective and creative use of pen marks; thick, thin, short and long. The tree branches, reflections in the stream and the birds in the sky all add to the sense of pattern and dynamism.*

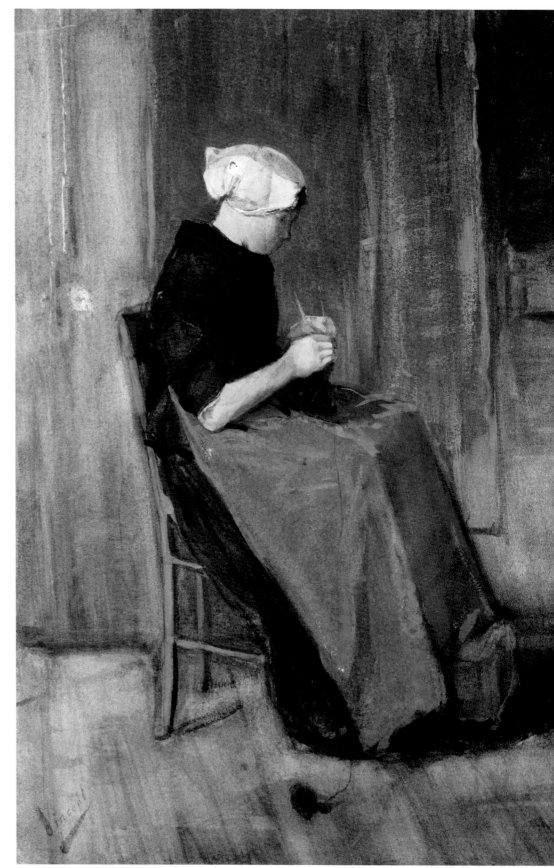

Young Scheveningen Woman Knitting, Facing Right, 1881. *Clearly influenced by Millet, Vincent painted this composition of a plainly dressed young woman knitting in a fairly empty room. He depicts her as poor but clean, dignified and diligent. She sits upright on her chair on the bare floorboards, her hair neatly concealed under a crisp white scarf, concentrating on her task in hand. The minimal palette augments the purity and simplicity of the scene.*

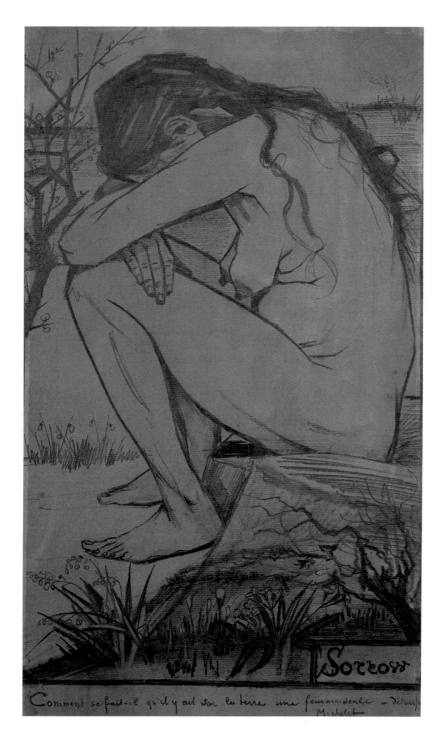

Sorrow, 1882. Vincent's relationship with Sien was complex. In some ways, he felt that he was fulfilling a Christian act of charity, in others, he was fulfilling his own needs. Either way, the relationship was unsuccessful, but he made more than 50 drawings of Sien and her family.

PAINFUL AFFAIR

In the early weeks of 1882, Vincent met a 32-year-old woman with a five-year-old daughter. Clasina Maria Hoornik, known as Sien, was a seamstress, an artists' model and a prostitute. She was also pregnant, and had various mental and physical health problems. She became Vincent's model and lover and at some point that spring, she moved into his rented studio. His friends and family, including Mauve, were shocked, but Vincent felt sorry for her, and was determined to take care of her and her children. He wrote to Theo: 'When I first came across this woman, she caught my eye because she looked so ill. I made her take baths and as many restoratives as I could manage, and she has become much healthier.' Although Theo did not approve of his brother's choice he continued to send him money, but Vincent's relationship with Mauve broke down. Describing Vincent as having a 'vicious character', Mauve forbade him to ever return to his studio. In June, Vincent suffered a severe attack of gonorrhoea and was admitted to hospital for several weeks. The following month, Sien's second child was born.

After a year and a half, they decided to part. Sien returned to her former life and Vincent wrote to Theo: 'I knew from the outset that her character is a ruined character, but I had hopes of her finding her feet and now, precisely when I don't see her any more and think about the things I saw in her, I increasingly come to realize that she was already too far gone to find her feet.' He left The Hague and travelled to Drenthe in northern Holland, a bleak area, where he drew and painted the heathland and moors, but after three months, the rain, cold and isolation became too much. In December 1883, he moved on to the Brabant district of Nuenen, where his father was pastor of the Dutch Reformed Church.

LIFE IN NUENEN

Theodorus and Anna allowed Vincent to live with them and set up a studio in one of the vicarage outbuildings, but their relationship was strained. He dressed and behaved strangely, and while Theodorus expected him to attend his church regularly he rarely did, which caused rows. However, in January 1884, when his mother broke her leg, Vincent attended to her as lovingly as he had nursed the sick in the Borinage.

Nuenen was a rural place, home to many farmers, labourers and weavers, and it provided Vincent with plenty of drawing and painting material. A retired goldsmith in the village, Anthonius 'Antoon' Petrus Hermans, had painted flowers on 12 panels in the dining room of his new house but had six panels left, and he asked Vincent to produce designs for him to copy. Vincent made some charcoal and oil sketches of farming scenes. The arrangement was that Hermans would copy Vincent's oil sketches, pay for the materials Vincent had used, and return the canvases after copying them so that Vincent could make finished paintings from them. However, it seems that Hermans probably did not return the oil sketches and it is unlikely that he paid Vincent for his materials either – but he did allow Vincent to draw and paint still lifes from his large collection of antiques.

During the time that Vincent lived in Nuenen, from December 1883 to November 1885, he produced a huge amount of work which amounted to approximately a quarter of his entire output. In early 1884, he suggested to Theo that he would send him drawings and paintings as payment for Theo's financial support. 'Let me send you my work and you take what you want from it, but I insist that I may consider the money I would receive from you after March as money I've earned,' he wrote. He thought Theo would sell the paintings in Paris, but French art buyers did not want them. However, at this time, he became enthused by the writings of Eugène Delacroix, and wrote to Theo: 'I am absolutely preoccupied by the laws of colour. If only they had taught them us in our youth … The laws of colour which Delacroix was the first to regulate and to bring to light … for the general use.' Yet despite his excitement, these ideas about colour did not appear in his work for at least two years.

Road Behind the Parsonage Garden in Nuenen, *1884. For Vincent, drawing was the basis of all art and his paintings closely follow his drawing style. He drew in pencil first, then created this eloquent drawing, using pen and ink, applying light and heavier lines, plus hatching, with some soft brushwork around the darker toned areas.*

The Parsonage Garden at Nuenen in Winter, 1884. *Although Mauve had taught him painting, during his two years in Nuenen, Vincent set himself a programme of learning that followed the traditional curriculum of initially focusing on drawing. This is his parents' garden.*

The Vicarage at Nuenen, 1885. *Observed from across the road, Vincent depicted the vicarage where his parents lived, and where he stayed. They gave him a room at the back to use as a studio. Here, he captured it in semi-shadow from the tall trees on a dull autumn day, the stone frontage and russet leaves painted with the earthy palette inspired by Rembrandt. The two women talking are probably his mother and sister.*

DRAMA AND DISTRESS

Vincent's studio in his parents' house was small and clashes with his family were frequent, so from May 1884, he rented a room as a studio from a Catholic sexton in the village, Johannes Schafrat. That summer, he had a brief relationship with a neighbour, Margaretha 'Margot' Begemann. Fragile and highly strung, Margot fell in love with Vincent and he proposed marriage, although their parents disapproved. Margot's family believed she was too old for marriage at 43 and arranged to send her away. On the eve of her departure, she met Vincent in a field where she collapsed into spasms. She had taken strychnine. Vincent forced her to vomit and rushed her to a local doctor who administered an antidote, and her family whisked her away to Utrecht to keep the incident private.

A few months later, at the end of March 1885, Theodorus died unexpectedly of a massive stroke. The funeral was on Vincent's 32nd birthday and it was noted that he behaved with an odd detachment while the other mourners were riven with grief. Several recalled Theodorus's frustrated cries during his many rows with Vincent, such as: 'I cannot bear it' and 'You will be the death of me,' and Vincent's sister Anna accused him of killing their father. He immediately left the vicarage and moved into his studio in Schafrat's house.

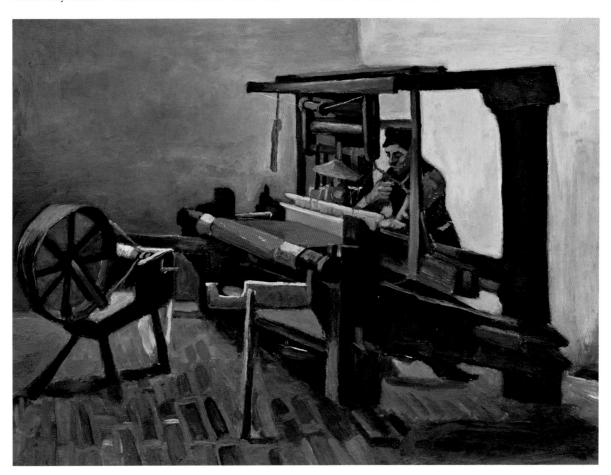

Weaver, 1884. Fascinated by the structure of a loom in contrast with the figure working at it and by contrasts in tones, Vincent executed several drawings and watercolours and at least ten oil paintings of the weavers who worked in and around Nuenen.

Congregation Leaving the Reformed Church in Nuenen, *January–February 1884 and autumn 1885. When his mother was in bed with a broken thigh bone in early 1884, Vincent made a painting of the church at Nuenen as a gift for her. In the autumn after his father's death the following year he revised the painting, making the scene autumnal rather than its original wintry depiction and adding a congregation with a woman in mourning where there had formerly been a labourer.*

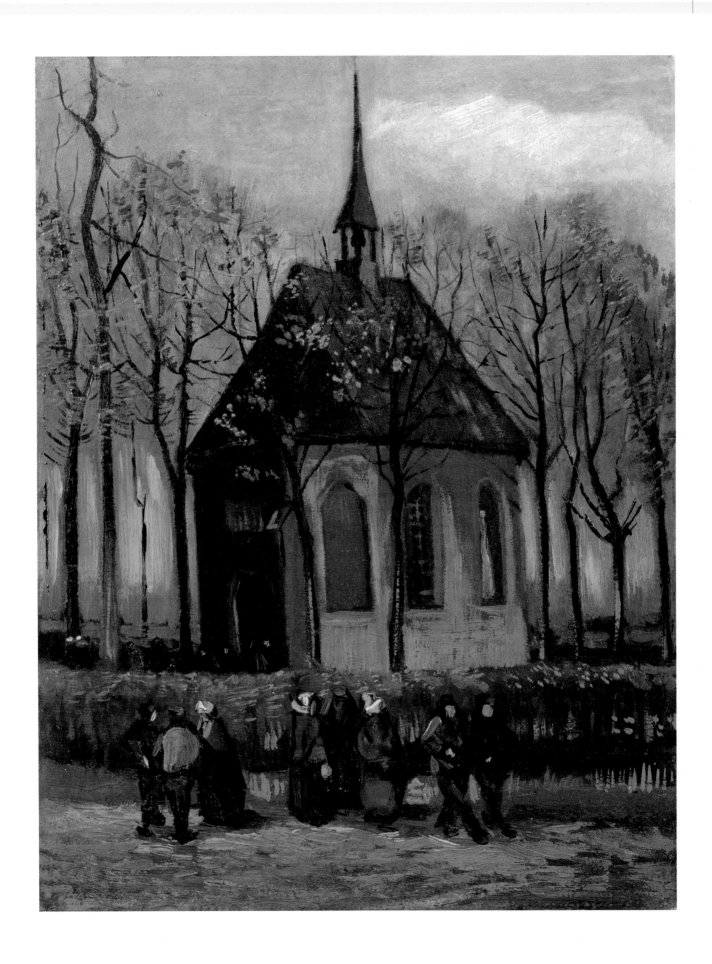

DEPICTING THE POOR

Vincent was one of a growing number of artists who sought to show social exclusion and the despair and indignities of the poor in nineteenth-century Europe rather than following the accepted approach of painting conventional and idealized beauty. Initially, when the Pre-Raphaelites in the UK, the Realists in France and the Hague School in the Netherlands began depicting the poor, their work was criticized as being ugly and dull, but with the rapid industrialization of many European countries, empathy for those who spent their days engaged in manual labour appeared in paintings by artists such as Daumier, Courbet, Ford Madox Brown and Edgar Degas. These paintings were often copied by engravers and reproduced in popular magazines such as *The Graphic* and *The Illustrated London News* from where they became widely known, and many achieved what the artists aimed for; a collective conscience.

In his paintings of rural peasants, Vincent conveyed his deep affinity with those who lived in poverty. For his painting *The Potato Eaters*, he made over a hundred portrait studies of farmworkers and peasants, plus other sketches and drawings and two oil studies of a poor family. Bringing together many of his interests, including the poor, figure studies and Rembrandt-type effects of light, he considered this to be his first real painting. It is the most significant of all his early works and it marked a turning point in his career and life. With their worn, tired faces, the five peasants sitting around the rough wooden table convey their daily hardships, as he wrote: 'I really have wanted to make it so that people get the idea that these folk, who are eating their potatoes by the light of their little lamp, have tilled the earth themselves with these hands they are putting in the dish ... that they have thus honestly earned their food.' He used a limited palette of dark earth colours and made each person's skin 'like the colour of a really dusty potato, unpeeled of course'. His portrayal is empathetic, but the story behind the image is once

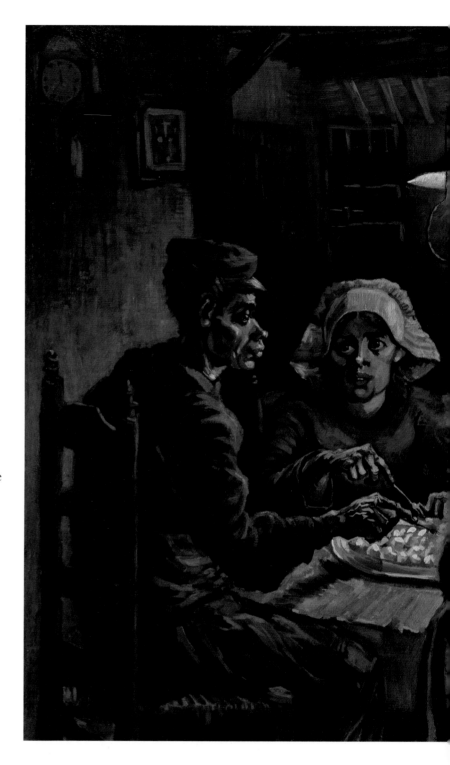

again fraught with his own personal difficulties.

The models were the de Groot family, whom Vincent had befriended. The family consisted of the mother Cornelia; her children, Hendrikus, Peter and Gordina, and Gordina's son Cornelis. Vincent made at least 20 studies of Gordina, and when her pregnancy became

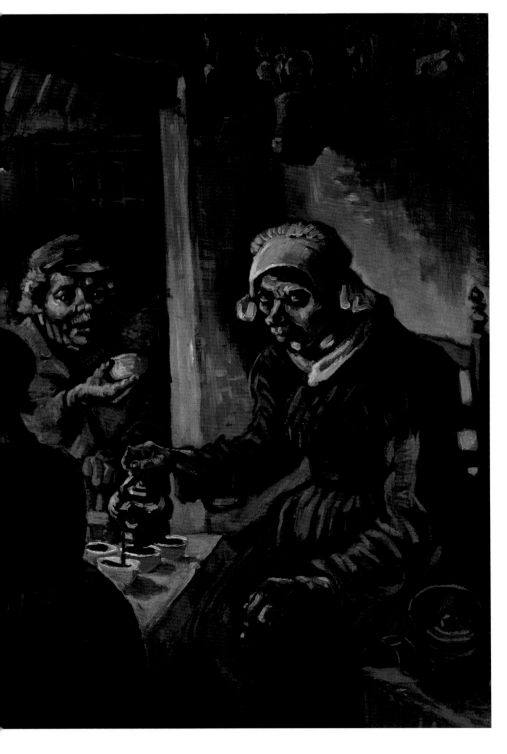

Head of a Woman, *1885. In the winter of 1884–5, Vincent painted more than 40 studies of peasant heads. He chose models with 'coarse, flat faces, low foreheads and thick lips, not sharp but full'. The contrast of their white headdresses against their grimy faces intrigued him. This is Gordina de Groot who also features in* The Potato Eaters *and inspired so many negative rumours around Vincent.*

The Potato Eaters, *1885. Generally now considered to be Vincent's first masterpiece, this painting took him weeks of preparation. Afterwards, he wrote to his sister Wil: 'I consider the picture of the potato-eating farmers that I painted in Nuenen to be,* après tout, *by far the best that I have ever painted.'*

apparent in September 1885, months of rumours burst forth. Overwhelmingly, Vincent was thought to be responsible and although he denied any involvement, few believed him. The parish priest implored him to stop associating with the lower classes and asked local workers to stop modelling for him.

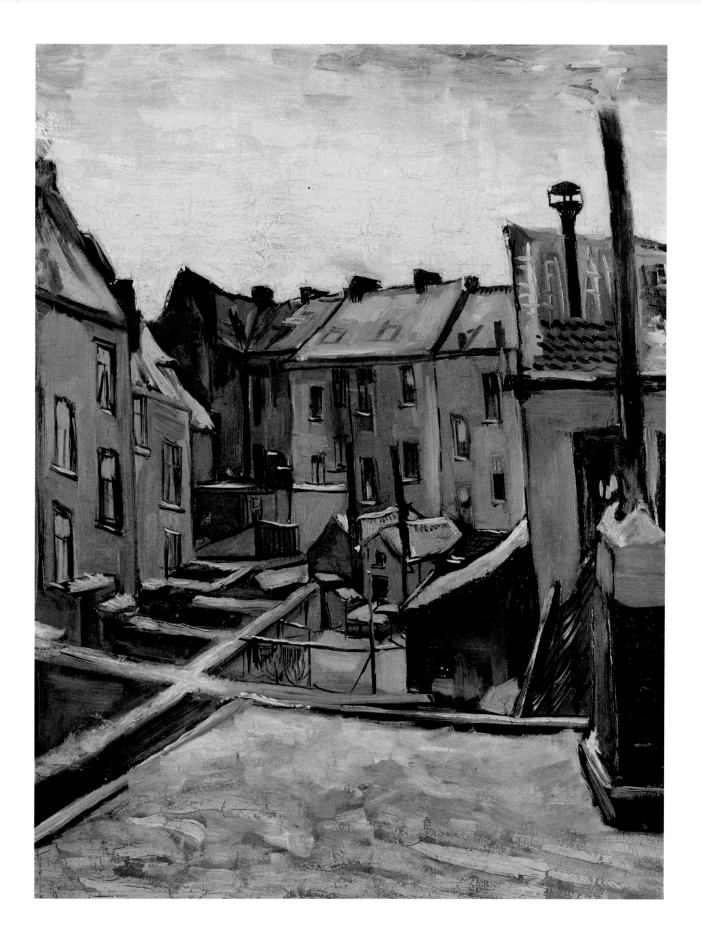

LIFE IN ANTWERP

In August 1885, Vincent's work had been publicly exhibited for the first time, in the shop windows of the framer and art supply dealer Wilhelmus Johannes Leurs in The Hague. At the end of November, because the accusations and scandal about him and Gordina were still making things difficult for him, he left Nuenen and moved to Antwerp. There he rented a room above a paint merchant's shop and spent time walking along the quays and visiting churches and museums. He approached various art dealers in the hope of selling his work, but none were interested, so he continued to live off the money that Theo sent him. He shared lodgings with the British artist Horace Mann Livens, and in January 1886, they both enrolled on a course in drawing at the Academy of Fine Art. Vincent also briefly attended a painting course there taught by Charles Verlat and two life drawing clubs in the evenings. With little money, he ate poorly, often just bread and water, while smoking his pipe heavily and spending most of the money that Theo sent him on painting materials and models. Within a few months, he had to have several teeth extracted as they had become loose. He also spent a short time in hospital, possibly being treated for syphilis.

Of all the art he saw there, the paintings by Rubens captivated him the most. He wrote to Theo about Rubens: 'His means are so simple, he paints and particularly draws with such a quick hand and without any hesitation.' After studying Rubens's palette, he wrote: 'Colour is not everything in a picture, [but] it is what gives it life.' To his own earthy palette, he added carmine, cobalt blue and emerald green. He also acquired his first Japanese ukiyo-e woodblock prints as they were being sold cheaply in Antwerp's docklands. However, although his lessons at the Academy were intended to continue until March 1886, in February he packed his bag and left Antwerp altogether.

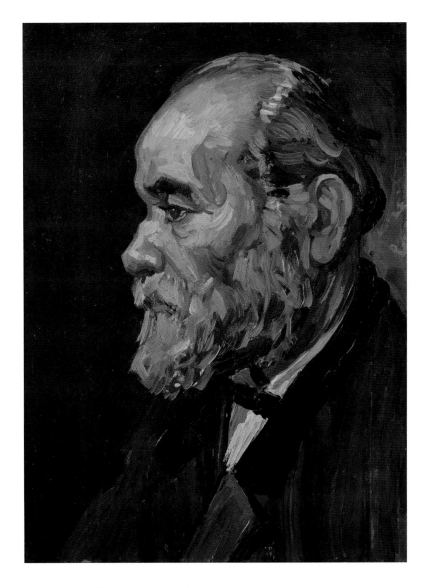

Portrait of an Old Man, *1885. While living in Antwerp, Vincent wrote to Theo: 'I have an appointment for tomorrow with a splendid old man — will he come???' It seems that he did, and Vincent painted this portrait of him using rough, thick brushmarks.*

Houses Seen from the Back, *1885–6. While he was in Antwerp, Vincent's palette lightened almost imperceptibly. With a thin layer of snow on the rooftops, this is the back view from the house where he was renting a small room.*

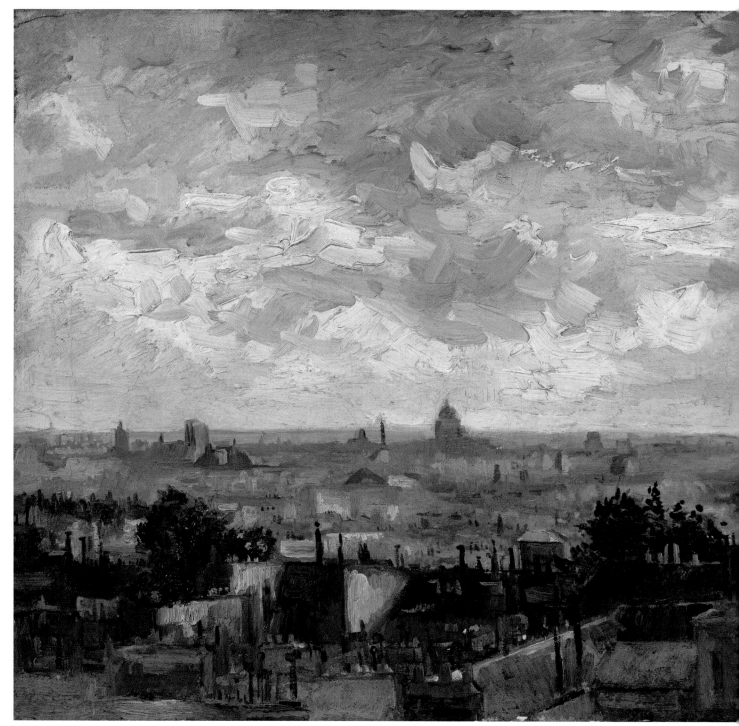

CHAPTER 3
Vincent in Paris

After three months in Antwerp, Vincent wrote to Theo that he planned to travel to Paris, hoping to take lessons with Fernand Cormon. Theo replied that his apartment was too small, so it would be best if Vincent were to remain in Antwerp until after 1 June, when the lease of his apartment would end and they could move into a larger place together. However, Vincent turned up unexpectedly, and sent Theo a note saying: 'Don't be cross with me that I've come all of a sudden. I've thought about it so much and I think we'll save time this way.' There was nothing to be done; they both squeezed into Theo's small apartment at 25 Rue Laval (now Rue Victor Massé) at the foot of the *butte* (hill) of Montmartre.

By the late nineteenth century, artists, intellectuals, musicians, writers and students all flocked to Montmartre, to the north of the centre of Paris. Inexpensive and with plenty of cafés, bars, cabarets and café-concerts, it buzzed with life. At the top of Montmartre there was once a rural village, and some picturesque vineyards and windmills remained, as well as narrow, winding streets.

View of Paris, 1886. Painted about three months after Vincent's arrival in Paris, this view is from the hill of Montmartre. Continuing to show his skills with both linear and aerial perspective, he applied rapid brushmarks and thicker paint with each colour. This impasto technique shows clearly in the yellow-white clouds.

AT CORMON'S STUDIO

Vincent began studying at Fernand Cormon's studio on Boulevard de Clichy. Cormon was an academic painter whose work was regularly shown at the annual Salon. In his 'open studio' he tried to guide his students to create paintings that would be accepted by the Salon's jury, but he also encouraged a more avant-garde approach, such as painting *en plein air*. Each day he set up casts of antique sculptures or brought in nude models and then went into the next room to paint, returning periodically to advise his students.

Among fellow students whom Vincent befriended at Cormon's were the French artists Henri de Toulouse-Lautrec, Louis Anquetin and Émile Bernard, the Australian John Peter Russell and Archibald Standish Hartrick, a Scot who later described Vincent as 'red haired, with a goatee, rough moustache, shaven skull, eagle eye, and incisive mouth … medium height, stocky without being in the least fat, lively gestures, jerky step … with his everlasting pipe, canvas, engraving or sketch … He had an extraordinary way of pouring out sentences in Dutch, English and French, then glancing back over his shoulder and hissing through his teeth.'

For four hours each morning, Vincent drew and painted at Cormon's. In the afternoons, he either returned and worked alone or visited the Louvre and Luxembourg galleries. Although he had planned to stay at Cormon's for three years, in the summer of 1886 he ceased to attend, writing: 'I have been in Cormon's studio for three or four months, but did not find it as useful as I had expected it to be.'

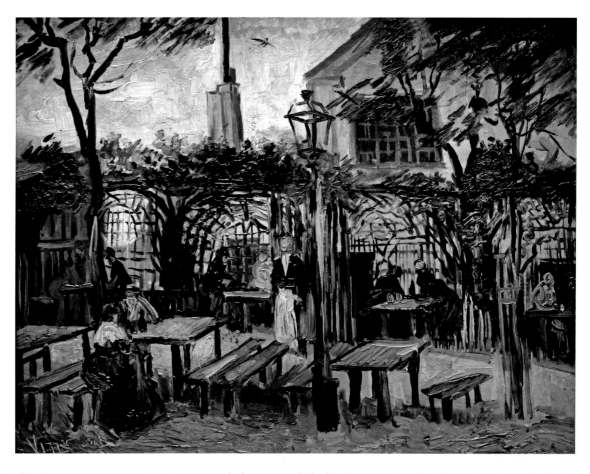

The Tavern in Montmartre, 1886. *Painting in the low autumn light that he was used to from his work in the Netherlands, Vincent captures this scene in bohemian Montmartre loosely, employing the calligraphic strokes that he used for his pen and ink works. However, not all is dark and sombre; already he is lifting his palette, working with cooler colours, such as the touches of pale blue and aqua that contrast sharply with the areas of dark brown and black.*

THE SALON DES INDÉPENDANTS

Until 1884, the only public art exhibitions in Paris were the official Salons of the Academy of Fine Arts, held each spring. To exhibit at the Salon, artists had to conform to the jury's conservative tastes, so artists who had progressive or non-traditional ideas were frequently rejected. Yet in order to be noticed and attract buyers, artists had to exhibit their work. This created obvious difficulties for artists who wanted to try more original ways of working, so to address this, in 1884, Georges Seurat and some other avant-garde artists founded their own society called the Société des Artistes Indépendants. From that year, they also held an annual exhibition called the Salon des Indépendants, that directly opposed the rigid submission policy of the Salon. With their slogan 'No jury, nor awards' (*Sans jury ni récompense*), the aim of the Salon des Indépendants was to enable all artists to exhibit their work to the public with complete freedom.

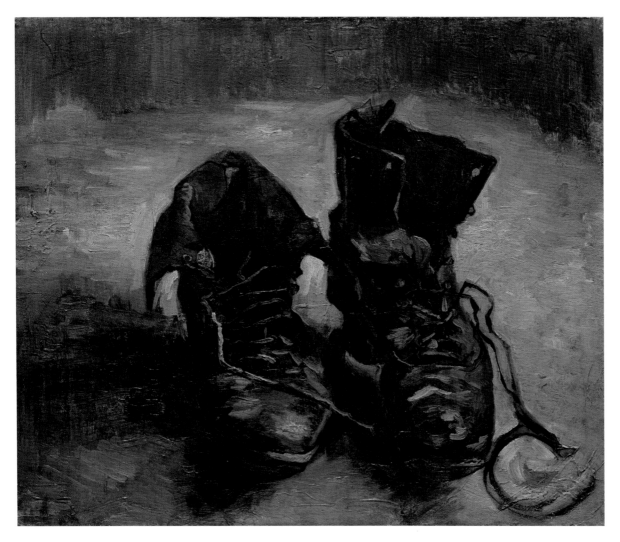

Shoes, *1886.
Vincent made
five paintings
of old shoes
between 1886
and 1887. These
came from a
flea market
but he thought
they looked too
new, so he wore
them for several
weeks until they
became dirty and
weathered.*

Vincent van Gogh, *John Peter Russell,*
1886. One of the friends Vincent made
at Cormon's studio, Russell painted the
words 'Vincent, in friendship' in red
above this portrait.

RELATIONSHIPS

Although Vincent was not pleased with the teaching at Cormon's studio, the friends he made there helped his artistic development. Partly through their influence, he began to use lighter, brighter colours and new painting techniques. They introduced him to other avant-garde artists, including Paul Gauguin, and Russell and Toulouse-Lautrec both made portraits of him.

Yet in general, Vincent's relationships were still often difficult. Some of the artists from Cormon's avoided him, and many of the models who happily sat for Cormon and others refused to do the same for him. With his friends, he began frequenting the Café du Tambourin on the Boulevard de Clichy which was run by Agostina Segatori, a sultry Italian woman who modelled for several of the artists and also ran a side business in prostitution. She and Vincent had a brief relationship and she persuaded some girls to model for him, but they soon stopped and he ended up either drawing from casts or painting self-portraits. Le Tambourin was also where Toulouse-Lautrec created a pastel portrait of Vincent, and where Vincent painted a portrait of Agostina. Before their relationship ended badly, Agostina arranged with Vincent that he would decorate her café, and in March 1887, he exhibited his collection of Japanese prints there.

Vincent also became close friends with Julien Tanguy, known as Père Tanguy to his friends, who ran a small paint supplies shop. Tanguy often accepted paintings in exchange for pigments, and his shop became a lively meeting place for artists. Vincent bought his art supplies from Tanguy and painted three portraits of him. Tanguy also often exhibited paintings by struggling artists, and in September 1886, he exhibited some of Vincent's. However, his paintings were hung among all the other shop clutter, including art materials for sale and other customers' canvases, and so were hardly noticed.

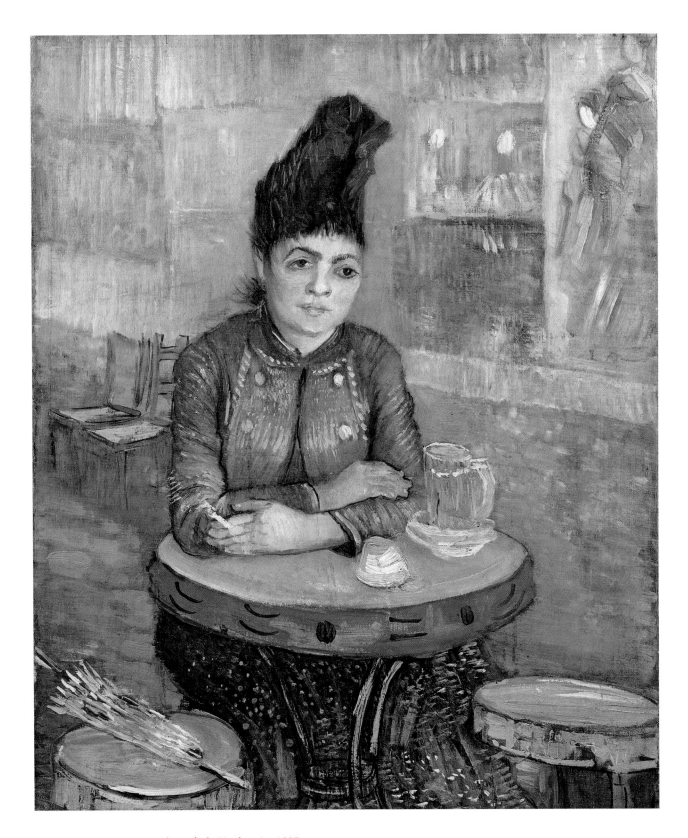

Agostina Segatori Sitting in the Café du Tambourin, *1887.*
Vincent painted Agostina Segatori in her café, sitting at a small
tambourine-shaped table. Behind her on the walls are some of
his Japanese prints that he had displayed for an exhibition.

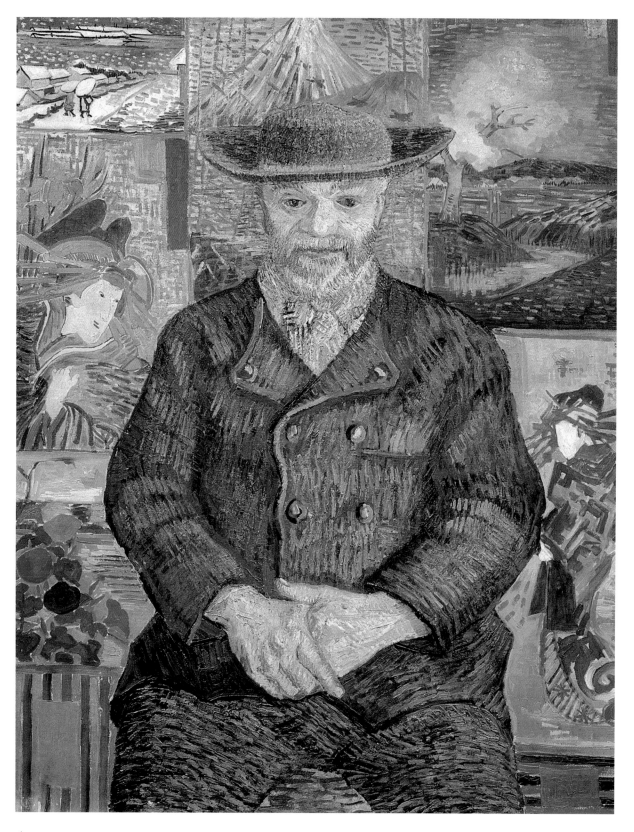

Père Tanguy, *1887–8. Vincent painted Père Tanguy sitting in front of numerous colourful ukiyo-e prints. They show Vincent's interest in the art of Japan, but he did not follow its style; he was developing a unique approach to painting.*

The Hill of
Montmartre,
1886. Although
Montmartre had
many bars, cabarets
and restaurants,
it was also still
fairly undeveloped.
Vincent often
painted it
from different
viewpoints. It can
be seen that his
palette continued
to follow artists
such as Corot and
Daubigny rather
than Monet or
Sisley.

INSPIRED BY THE AVANT-GARDE

Émile Bernard was 18 years old when he became
friends with 33-year-old Vincent at Cormon's
studio. Bernard formed his own artistic approach,
one that opposed Cormon's, and Cormon
dismissed him. Bernard's style differed from both
the traditional, academic approach and from
the new, radical styles of Impressionism and
Neo-Impressionism. Instead, he painted with
flat-looking colours and dark outlines, a style
that became known as Cloisonnism. After seeing
Bernard's work, Vincent simplified his compositions
and style.

The influences worked both ways. After
Vincent's exhibition of Japanese prints at the Café
du Tambourin in March, he wrote to Theo: 'The
exhibition of prints that I had at the Tambourin
influenced Anquetin and Bernard a good deal.'
That July, he put on another exhibition at the
café displaying his own paintings and some
by Gauguin, Toulouse-Lautrec, Anquetin and
Bernard. Vincent and Bernard regularly exchanged
paintings, drawings and letters; Bernard later
described Vincent as 'the most noble character of

man you could ever meet, frank, open, lively to
be with, a certain touch of malice, funny – a good
friend, inexorable judge, devoid of all selfishness
and ambition'.

Before he arrived in Paris, Vincent had imagined
how much the city would help him to realize his
dream of becoming a successful artist. There he
hoped to see the works of the revolutionary painters
he had heard about from Theo, and it was through
Theo and Tanguy that he became acquainted with
several avant-garde artists including Paul Cézanne,
Édouard Manet, Camille Pissarro and Claude
Monet. He was also hoping to study at first hand
the paintings of those artists he already admired,
including Delacroix, Rubens, Millet and Corot.
For the first few months, all went well; he settled
down, made new friends, visited galleries, practised
drawing and painting, and his health improved.
As Theo was now the manager of the Parisian
gallery Boussod, Valadon & Cie (renamed after
the retirement of Adolphe Goupil), he was able to
buy avant-garde paintings including some by the
Impressionists, although when Vincent arrived in
Paris only one, by Alfred Sisley, was on display.

IMPRESSIONISM AND NEO-IMPRESSIONISM

Since 1874, the artists known as the Impressionists had painted with short brushstrokes and vivid colours, depicting the effects of light and transient moments. Vincent had not seen any paintings by them until the summer of 1886, when he visited their last independent exhibition in Paris. Although several of the most well known Impressionists did not participate in this show, including Monet and Pierre-Auguste Renoir, those who took part included Degas, Mary Cassatt, Berthe Morisot, Armand Guillaumin and Camille Pissarro. The following month Vincent visited the fifth Exposition Internationale, organized by the art dealer Georges Petit, and was captivated by the colours, sketchy brushmarks and evocation of light in paintings by Monet and Renoir.

At the Impressionist Exhibition, younger artists included Gauguin, Lucien Pissarro, Paul Signac and Georges Seurat. Most critics focused on two aspects: some pastels by Degas of women bathing, and Seurat's monumental painting *A Sunday Afternoon on the Island of La Grande Jatte*, which dominated the show. In his review of the show, the French art critic Félix Fénéon invented the name 'Neo-Impressionism' to describe the scientific way in which Seurat, Signac, Pissarro and some others used colour. Seurat's painstaking new technique of applying only dots of pure colour became known as pointillism or divisionism. When seen from a distance, these separate, unmixed colours create a shimmering effect.

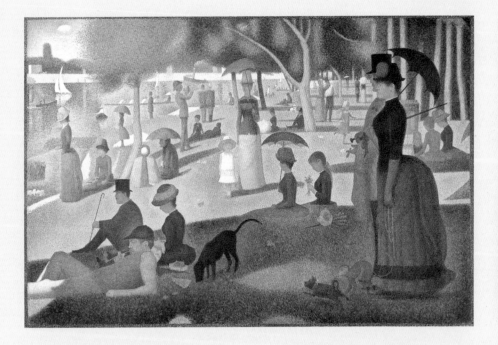

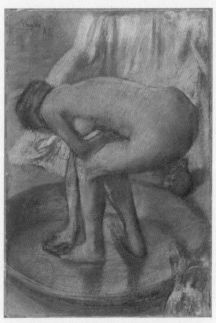

A Sunday Afternoon on the Island of La Grande Jatte, *Georges Seurat, 1884–6. In this vast painting Seurat perfected his pointillist technique, applying dots of pure pigment across the canvas to achieve colours and tones by optical effects rather than through physical mixtures of paint. It dominated the eighth Impressionist Exhibition, it inspired the name Neo-Impressionism, and the science of the colour juxtapositions fascinated Vincent.*

Woman Bathing in a Shallow Tub, *Edgar Degas, 1885. This was one of the bathing nudes exhibited by Degas at the eighth and final Impressionist Exhibition in 1886. Critics denigrated them, but Vincent admired them greatly.*

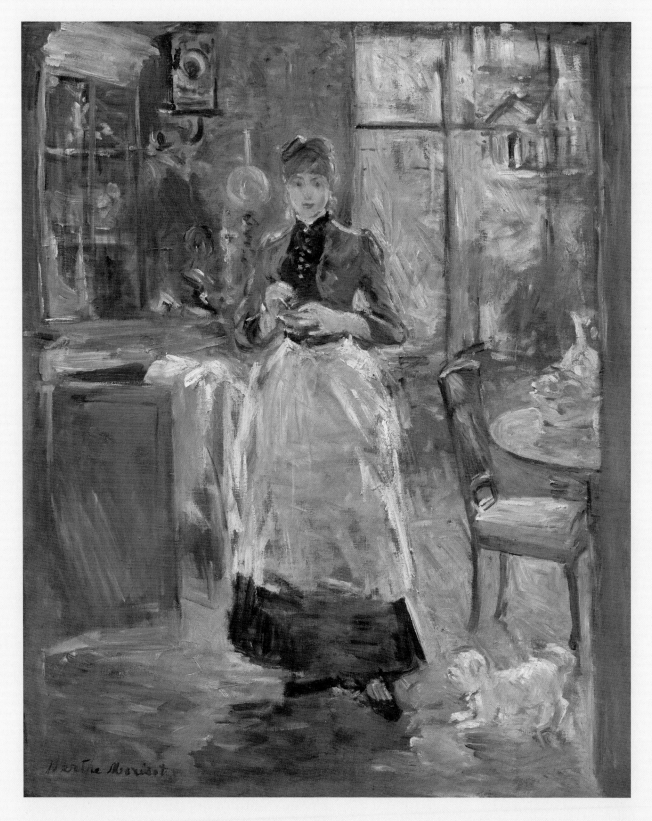

In the Dining Room, *Berthe Morisot, 1886. Despite all the restrictions*
that were imposed on Morisot as a female artist, she had successfully
exhibited at the Salon since she was 23 and was an important
Impressionist, exhibiting in five out of eight of their exhibitions.

JAPONISME

In Paris, Vincent collected more Japanese woodblock prints. He had begun to acquire them in Antwerp, when he had written to Theo: 'My studio's quite tolerable, mainly because I've pinned a set of Japanese prints on the walls that I find very diverting. You know, those little female figures in gardens or on the shore, horsemen, flowers, gnarled thorn branches.' The interest in Japanese ukiyo-e art was stronger in Paris than anywhere else, and Vincent and Theo soon built up a sizeable collection. Vincent began implementing ideas from them in his own work, such as bold outlines and colours, cropped elements at the edge of the frame and asymmetrical compositions.

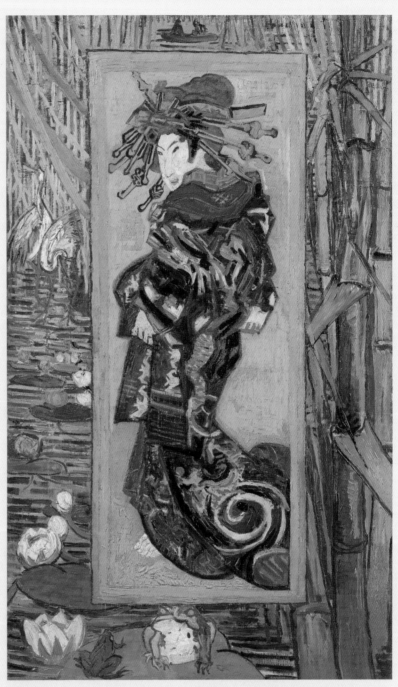

Courtesan (after Keisai Eisen), *1887. For this painting, Vincent traced a figure from the image* The Courtesan *(c. 1830) by the Japanese ukiyo-e artist Keisai Eisen, printed on the cover of the magazine* Paris Illustré. *He then enlarged the figure.*

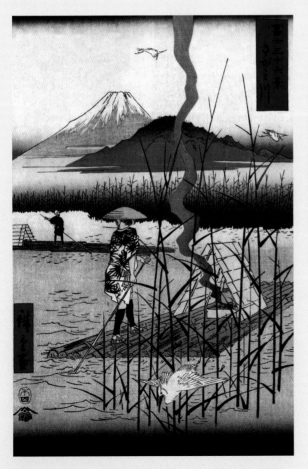

The Sagami River, *from the series* Thirty-Six Views of Mount Fuji, Utagawa Hiroshige, 1852. *Vincent possibly owned a print of this work by the Japanese ukiyo-e artist Utagawa (Andō) Hiroshige, one of a series of images that depict Mount Fuji in different seasons and weather conditions and from different viewpoints.*

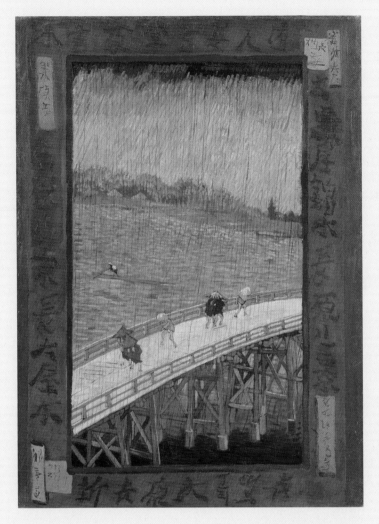

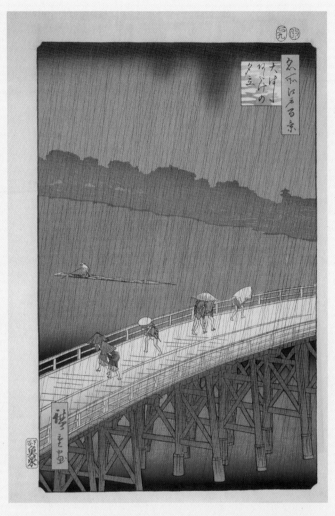

Bridge in the Rain (after Hiroshige), *1887. In 1887, Vincent made copies of two prints by Hiroshige, of which this is one. He used brighter colours than he had done until then and added borders decorated with calligraphic characters copied from other Japanese prints.*

Sudden Shower over Shin-Ōhashi Bridge and Atake, *Utagawa (Andō) Hiroshige, 1857. Part of the series* One Hundred Famous Views of Edo, *produced by Hiroshige between 1856 and 1859.*

The fashion for all things Japanese developed across Europe and the USA when Japan began trading with the Western world in the 1850s after more than 200 years of isolation. Ukiyo-e (Japanese for 'pictures of the floating world'), a style of painting and woodblock printing, was produced from the seventeenth to the nineteenth centuries, featuring sinuous compositions and flat colours. It became hugely influential to many artists, including James Abbott McNeill Whistler, Monet, Toulouse-Lautrec, Degas, Morisot, Bernard, Seurat, Gauguin and Vincent. The craze for Japanese art and design and its Western interpretations became known as Japonisme or Japonism, although Vincent's name for it was Japonaiserie.

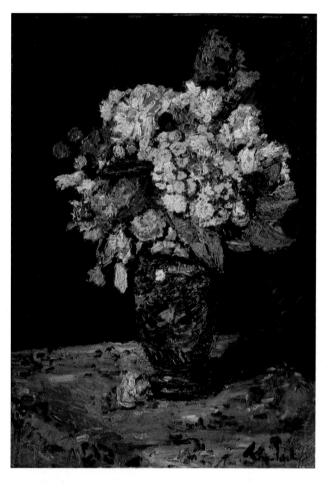

Flowers in a Blue Vase, *Adolphe Monticelli, 1879–83. Monticelli's composition, impasto and rich colours directly influenced Vincent in the series of flower paintings that he produced in 1886.*

CHANGING STYLE

As well as the Impressionists and Neo-Impressionists, while in Paris Vincent became greatly influenced by Delacroix. In two Parisian churches, he saw three works by him, *Pietà* (1844), *Jacob Wrestling with the Angel* and *Heliodorus Driven from the Temple* (1854–61), and was inspired by the lively execution and dramatic compositions. Adolphe Monticelli was another artist whose work greatly affected him. Born in the south of France, Monticelli had studied in Paris and painted regularly in the Forest of Fontainebleau with the Barbizon painter Narcisse Virgilio Diaz de la Peña. He used impasto paint and bold colours, and Vincent bought some of his paintings. In 1888, he wrote to Theo about Monticelli, 'Sometimes I think I really am continuing that man's work.' In 1890, he and Theo paid for the publication of a book about Monticelli's art.

Despite all these influences, it was only gradually over the following year that Vincent began to adopt brighter colours and shorter, more animated brushmarks. He had concluded that colour in painting should express emotion as well as convey visual experiences.

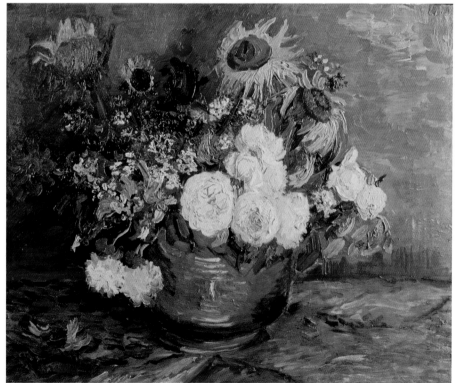

Sunflowers, Roses and other Flowers in a Bowl, 1886. *In the late summer and autumn of 1886, Vincent produced a series of flower paintings, of which this is one. His palette had changed to include brighter colours than he had used previously and his paint texture was thicker, with longer, more fluid brushstrokes than before, which was primarily due to his admiration of the work of Monticelli.*

ART IN ASNIÈRES

Early in June 1886, Theo and Vincent moved into a larger apartment on the fourth floor at 54 Rue Lepic. It had a small room at the back that Vincent used as a studio, and he soon covered the walls of the entire apartment with his own paintings, Japanese prints and paintings by artists that he and Theo collected.

In his studio he painted still lifes, portraits of friends and acquaintances, self-portraits, his casts of classical sculptures, and occasionally views from the apartment windows, although he preferred being on the streets of Montmartre where he felt as if he was part of the life around him. He often began paintings outside then finished them in his studio. He also made frequent trips to Asnières, a village on the banks of the River Seine 6 km (3¾ miles) north of Paris that was a popular spot for day-trippers and artists, including Seurat, Renoir and Monet. Émile Bernard lived there, and Vincent often worked in his garden studio. Another resident was Signac, with whom he became friends; under his influence, Vincent began painting in a pointillist style. Overall, he produced about 30 paintings and drawings in Asnières.

The Restaurant de la Sirène at Asnières, 1887. The town of Asnières became one of Vincent's painting locations during the summer of 1887. He drew and painted several views there, including this restaurant. His painting style was changing, but he had not yet acquired his later methods.

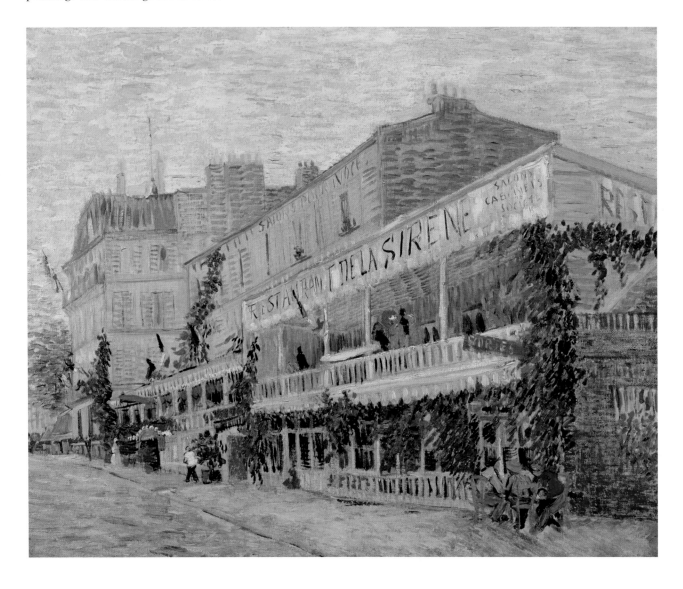

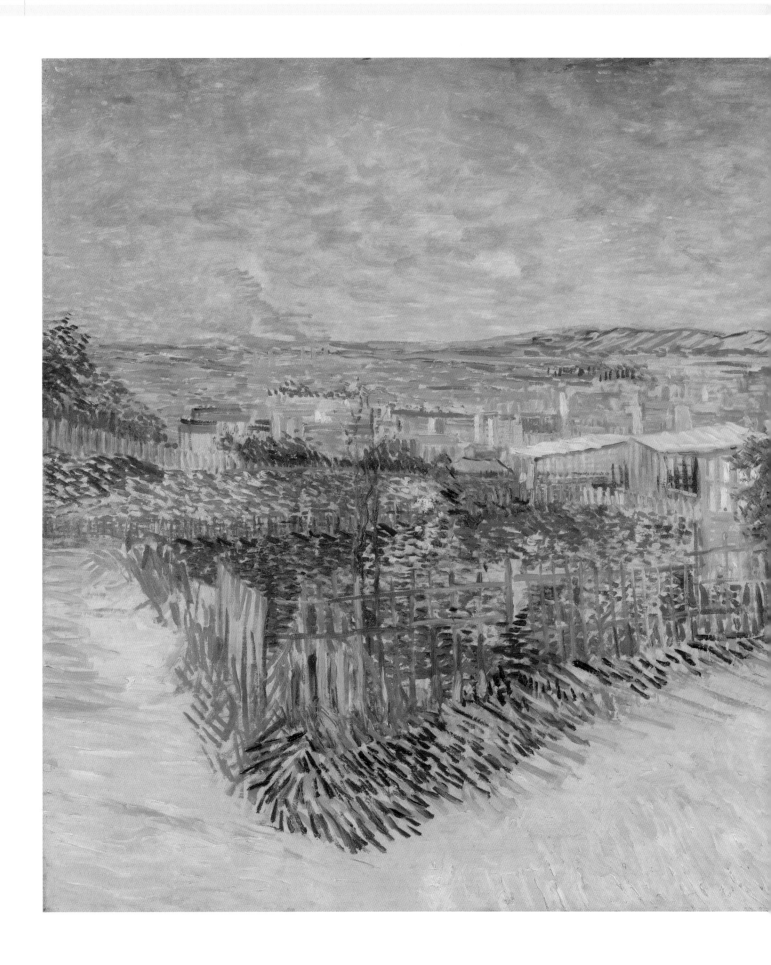

LEAVING PARIS

Despite the closeness between the brothers their relationship became strained, and in 1887, Theo wrote to their sister Wil: 'No one wants to come by any more because it always leads to rows, and he's so filthy and slovenly that the household looks anything but inviting. What I just hope is that he'll go and live on his own, he's spoken about that for a long time, because if I told him that he had to go it would be the very reason for him to stay.' Although they overcame their differences, Vincent was once again suffering the ill effects of tobacco and alcohol, and on 19 February 1888, tired of Paris, he left.

Montmartre: Behind the Moulin de la Galette, *1887. One of Vincent's largest landscapes, this is the hill of Montmartre, painted with experimental brushmarks on a light ground. In 1888, it was one of the three paintings he exhibited at the Salon des Indépendants (see page 41).*

Two Cut Sunflowers, *1887. In August 1887 Vincent painted his first sunflowers, his work showing influences of Japanese, Impressionist and Neo-Impressionist art. Here, he placed the yellow of the flowers against a deep blue background, abandoning his sombre earlier palette.*

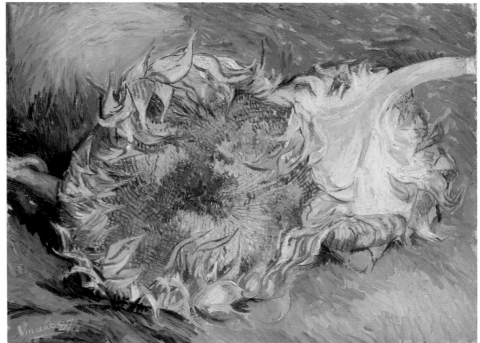

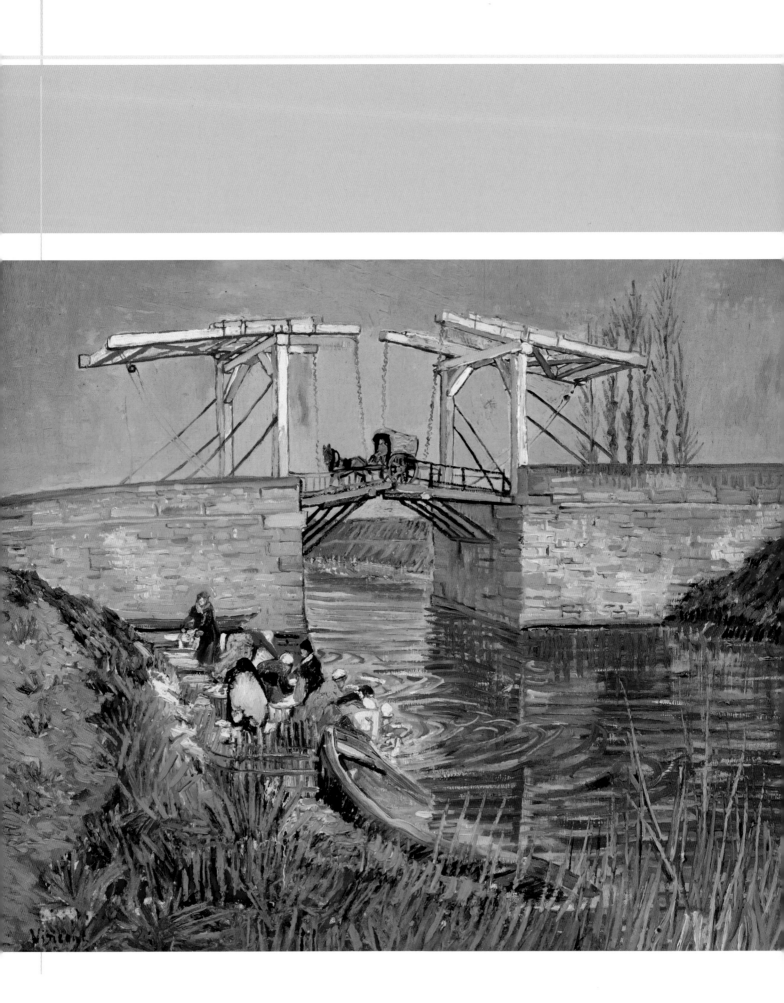

CHAPTER 4
Arles

Almost exactly two years after he had arrived there, Vincent left Paris. He was ill and tired of city life, and he believed he would find peace, light and colour in the south. He wrote to Theo: 'It seems to me almost impossible to work in Paris unless one has some place of retreat where one can recuperate and get one's tranquillity and poise back.'

It was not a completely selfish move. Also of delicate health, Theo had been ill the previous winter. His joints had stiffened, his facial features had swollen and he felt constantly exhausted. Coming from their strict religious background, both brothers perceived illness as a failing and a punishment. In addition, at the time they were clashing the most, Theo had said to Vincent, 'I only ask one thing, do me no harm.' When Theo's symptoms returned early in 1888, Vincent decided that because of his own physical and mental problems, he was killing his brother just as he believed he had killed their father.

NEW SURROUNDINGS

On 19 February 1888, Vincent took a 16-hour train journey from Paris to Arles, a small town on the River Rhône in Provence. It is not clear why he chose Arles. It may have been on the recommendation of Toulouse-Lautrec, Seurat or even Cézanne, whom he had met briefly at Tanguy's shop; perhaps it was the influence of Monticelli, who had grown up in the south. He arrived at the end of the coldest winter Arles had experienced in a decade, and a thick blanket of snow fell on his first night. He took a room at the hotel-restaurant Carrel, and wrote to Theo: 'The landscape under the snow … was just like the winter landscapes the Japanese did.'

Although he found the snowy town picturesque, most of the locals were less attracted by this tall, red-haired foreigner and even regarded him with suspicion. He wrote to Theo, Bernard, Toulouse-Lautrec and Gauguin, describing the townspeople: 'The Zouaves [French North African soldiers], the brothels, the adorable little Arlésiennes going to their first Communion, the priest in his surplice, who looks like a dangerous rhinoceros, the absinthe drinkers, all seem to me to be beings of another world.' The 'Arlésiennes' were local girls who fascinated him with their colourful shawls and black headdresses. He met and made friends with a Danish painter, Christian Mourier-Petersen, and they often painted together. At the end of March, largely through Theo, three of his paintings were exhibited at the Salon des Indépendants in Paris.

Bridge at Arles (Pont de Langlois), 1888. In March, Vincent painted this view of a wooden drawbridge using a vivid palette and slab-like brushmarks. The bridge was designed by a Dutch engineer and may have reminded him of his homeland.

PAINTING THE LANDSCAPE

At the end of May, Vincent travelled to the fishing village of Les Saintes-Maries de la Mer on the Mediterranean Sea, approximately 40 km (25 miles) south of Arles. For five days, he drew and painted boats at sea, the beach and other aspects of the small village. The simple houses there reminded him of huts he had seen in Drenthe, but the sea inspired him the most. He wrote to Theo: 'The Mediterranean has the colour of mackerel, changeable I mean. You don't always know if it is green or violet, you can't even say it's blue, because the next moment the changing reflection has taken on a tint of rose or grey.'

The following month, he painted *The Harvest* at La Crau, building on the influence of Millet. He wrote to Theo: 'What I learned in Paris is leaving me and I am returning to the ideas I had in the country before I knew the Impressionists.' As summer came, he spent a great deal of time painting outdoors, often at Montmajour, a hill to the north-east of Arles with an abbey at the top.

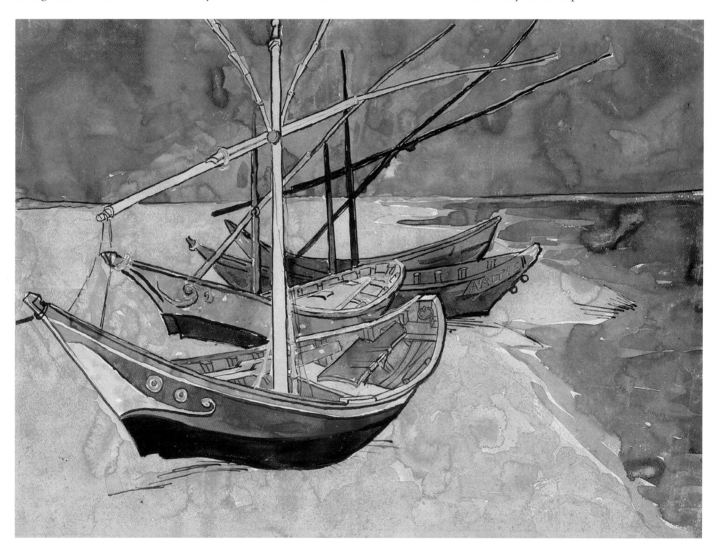

Fishing Boats on the Beach at Les Saintes-Maries de la Mer, 1888. Here the beach has been painted in a fairly textural manner, using thick and thin dilutions of watercolour and directional marks while the boats look two-dimensional with their bold, flat colours, strongly outlined contours and no cast shadows, recalling the Japanese ukiyo-e style.

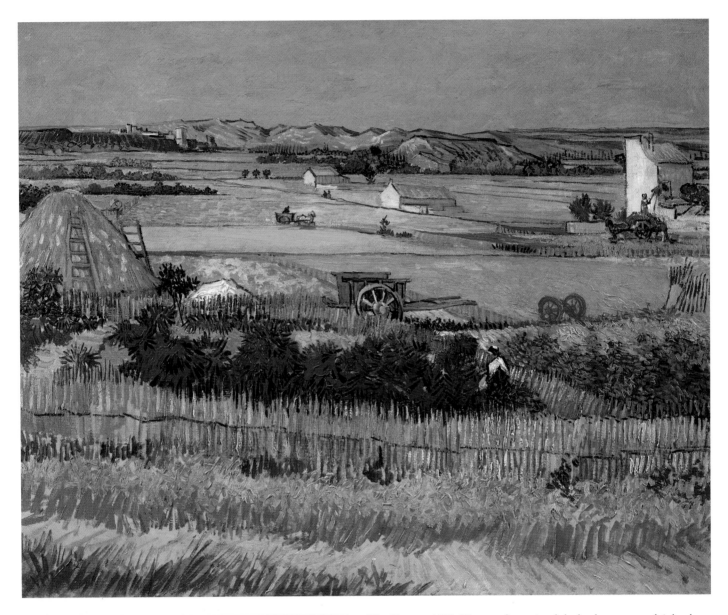

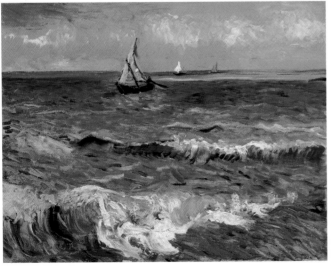

The Harvest, 1888. *Vincent often painted the landscape around Arles, here depicting a wheatfield on a summer day with colours in contrast to those in his earlier palette. Although rarely satisfied with his paintings, he felt that this was successful.*

Seascape near Les Saintes-Maries de la Mer, 1888. *This work has grains of sand in the paint that indicate it was created en plein air. Using loose brushstrokes and a palette knife, Vincent captured the effects of the wind on the water.*

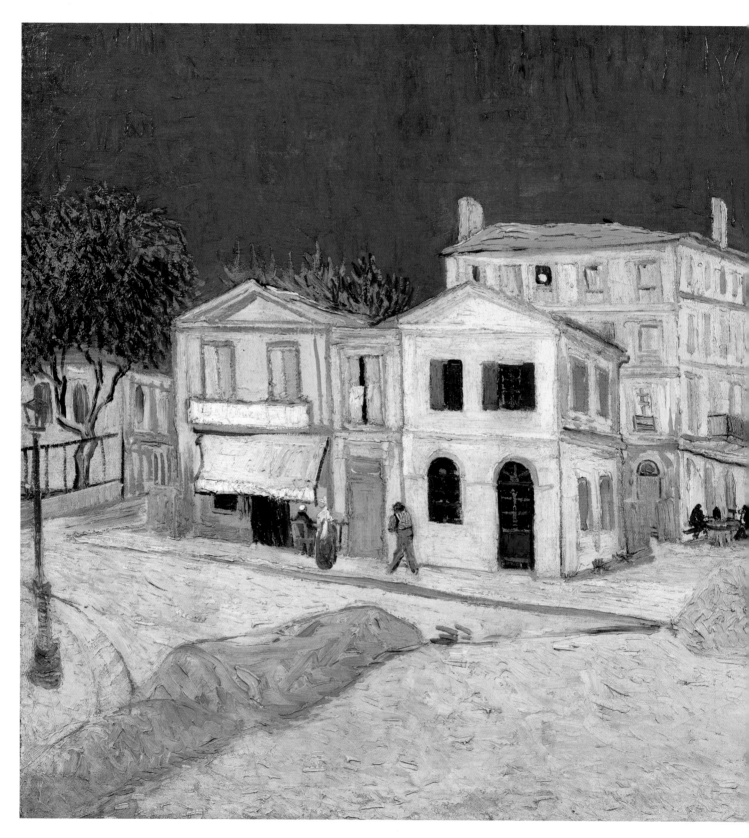

The Yellow House (The Street), *1888. This is Vincent's home at 2 Place Lamartine in Arles. The studio and kitchen were on the ground floor with two bedrooms above. On the left is the Auberge Venissac.*

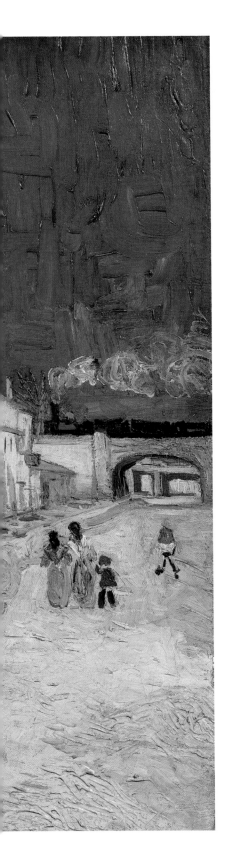

THE YELLOW HOUSE

Vincent had long dreamed of living in a community of artists who worked and exhibited together, thinking it would put an end to his loneliness and financial worries. This idea was in his mind when he began renting rooms in a building at 2 Place Lamartine in May 1888: 'It is painted yellow outside, whitewashed inside, on the sunny side. I have taken it for 15 francs a month,' he wrote to Theo.

The dilapidated building had been empty for two years and Vincent loved it. While the 'Yellow House' was being renovated he used only the ground floor as a studio and rented a room above the Café de la Gare nearby. He painted pictures for the walls, including *The Public Garden, The Night Café, The Yellow House (The Street), Starry Night over the Rhône* and four sunflower paintings. In September Theo sent funds for some furniture and Vincent moved in completely, making one upstairs room his bedroom and keeping the other for the artists he hoped would soon stay. He ate most of his meals in the Auberge Venissac next door and wrote to Wil: 'My house here is painted the yellow colour of fresh butter on the outside, with glaringly green shutters; it stands in full sunlight in a square that has a green garden with plane trees, oleanders and acacias. It is completely whitewashed inside, with a floor made of red bricks … In this house I can love and breathe, meditate and paint.'

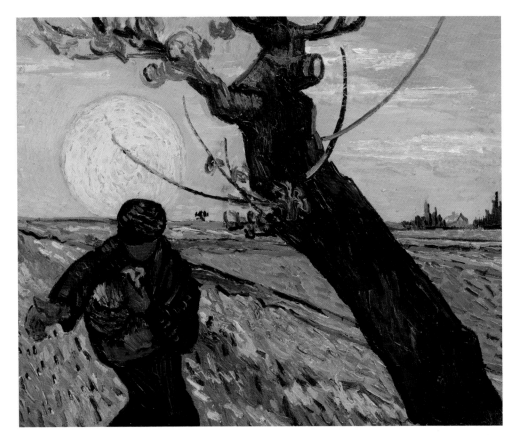

Sower with Setting Sun, 1888. *Vincent made several drawings and paintings of a sower in front of a setting sun. Using unnatural colours and a diagonal, dramatic composition, this shows the influence of Japanese prints.*

THE NIGHT CAFÉ

As a lodger upstairs at the Café de la Gare on Place Lamartine, Vincent became friendly with the owners, Joseph-Michel and Marie Ginoux. The café stayed open all night and in September, just before he moved into the Yellow House, Vincent painted the interior at a late hour. Around a billiards table, the walls are lined with tables and chairs, some occupied by customers. Standing by the billiards table in white is Joseph-Michel. The dominating colours are red, yellow and green, and Vincent's exaggerated perspective creates disorienting angles. He described the painting to Theo: 'In my picture of the Night Café I have tried to express the idea that it is a place where one can ruin oneself, go mad or commit a crime. So I have tried to express, as it were, the powers of darkness in a low public house, by soft Louis XV green and malachite, contrasting with yellow-green and harsh blue-greens, and all this in an atmosphere like a devil's furnace, of pale sulphur.'

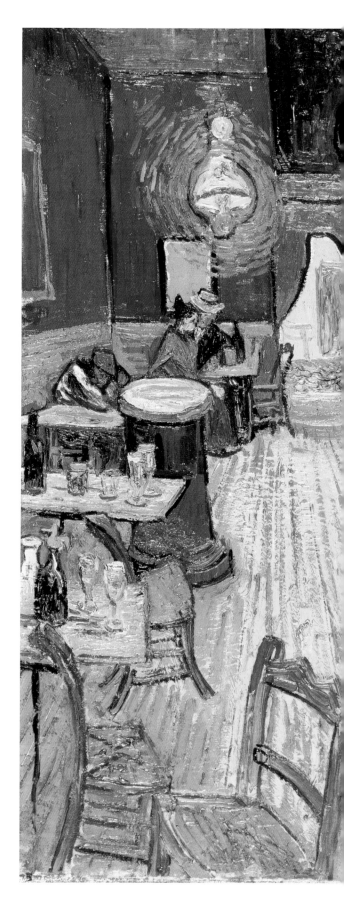

The Night Café, 1888. *Vincent spent three nights painting this room, sleeping during the day. He wrote to Theo about it: 'Everywhere there is a clash and contrast of the most disparate reds and greens.'*

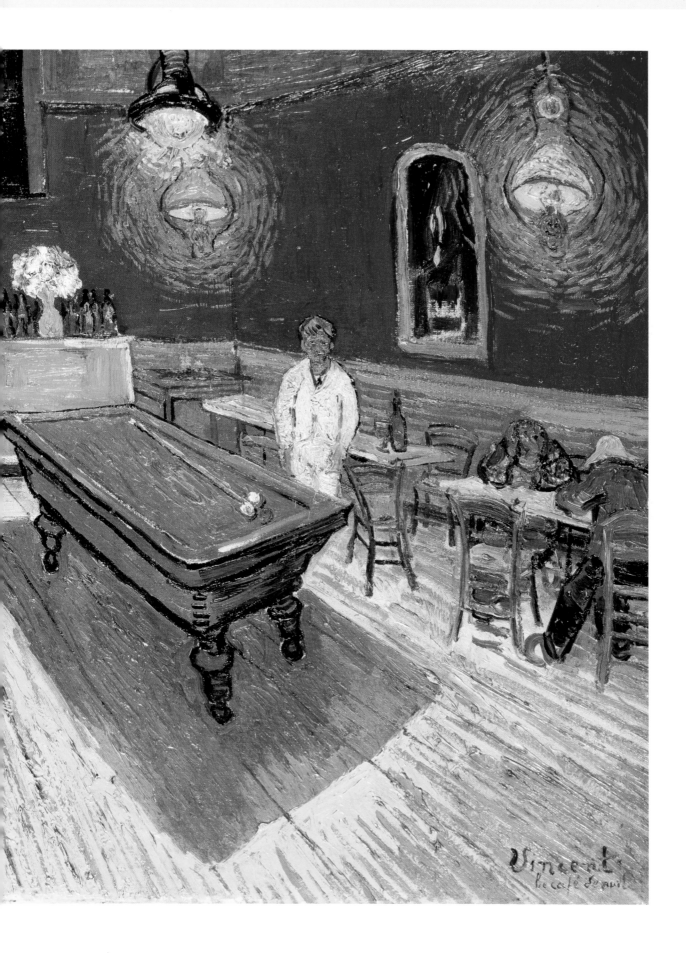

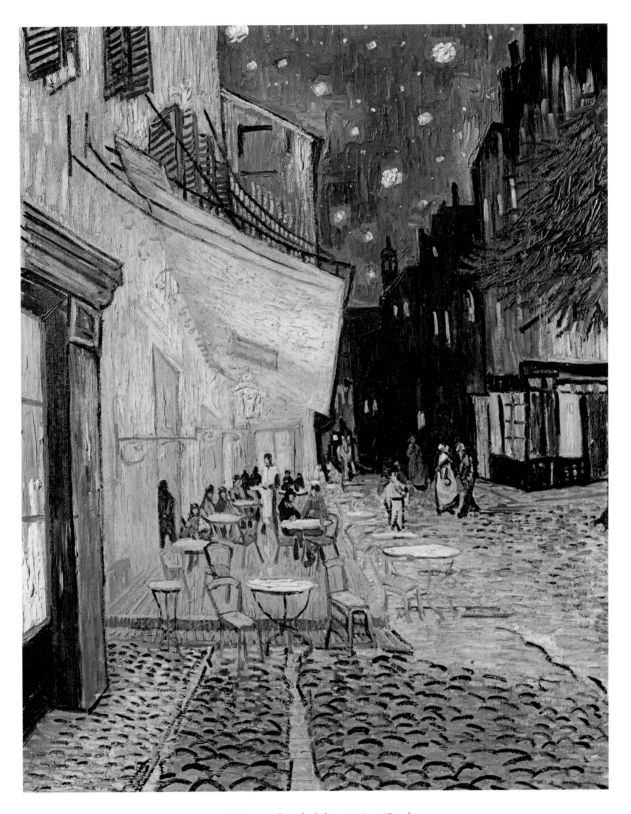

Café Terrace at Night, 1888. In a letter to Wil, Vincent described this painting: 'On the terrace there are tiny figures of people drinking. An enormous yellow lantern sheds its light on the terrace, the house and the pavement, and even causes a certain brightness on the pavement of the street, which takes a pinkish violet tone. The gable-topped fronts of the houses in a street stretching away under a blue sky spangled with stars are dark blue or violet.'

THE STUDIO OF THE SOUTH

In May, Vincent wrote to Theo: 'You know I've always thought it ridiculous for painters to live alone. You always lose when you're isolated.' The following month, he wrote about his health problems and loneliness, and Theo, worried about him, did all he could to make this dream of the 'Studio of the South' an actuality. After asking a few other artists to join him, Vincent eventually turned to Gauguin, who was reluctant – but when Theo agreed to pay his debts and travel expenses to Arles and to raise Vincent's monthly allowance while he lived there, Gauguin agreed. In return, Gauguin would send one painting a month from Arles for Theo to sell in Paris. Theo wrote to Vincent: 'So Gauguin's coming; that will make a big change in your life. I hope that your efforts will succeed in making your house a place where artists will feel at home.' Before Gauguin arrived, he and Vincent exchanged self-portraits.

Starry Night over the Rhone, *1888.* *Vincent described this painting in a letter to Theo: 'The starry sky painted by night. The sky is aquamarine, the water is royal blue, the ground is mauve. The town is blue and purple. The gas is yellow and the reflections are russet gold descending down to green-bronze.'*

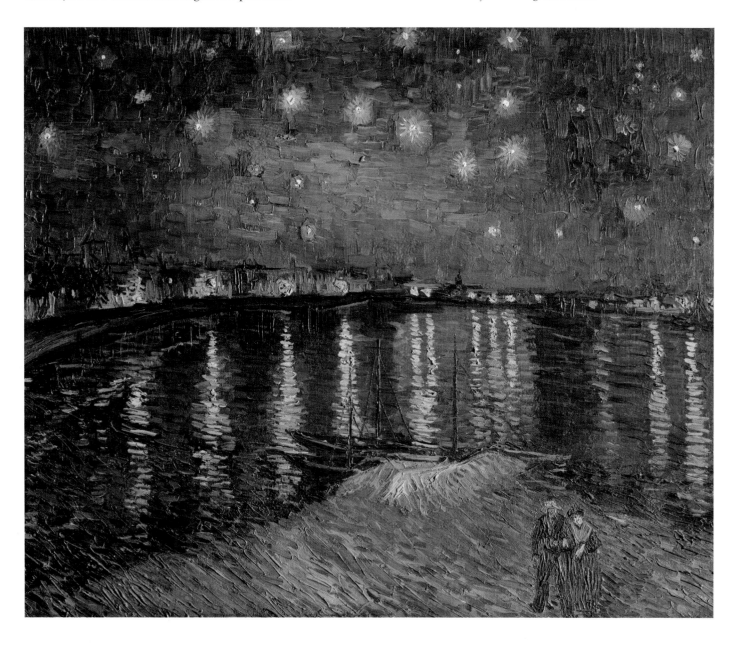

PAUL GAUGUIN

Gauguin was born in Paris in 1848. When he was a baby his father died, and he spent his childhood in Peru with his mother, sister and maternal grandmother. He joined the merchant navy as a teenager, spending five years at sea, and returned to Paris when he was 23. Through a wealthy friend of his mother's, he obtained a job as a stock exchange agent, and also met his future wife, a Danish woman named Mette-Sophie Gad.

Gauguin had begun painting in 1873, but after his marriage he turned to collecting art instead. Through this, he befriended Camille Pissarro, who encouraged him to paint once more and invited him to exhibit at the fourth Impressionist Exhibition in 1879. From that time, Gauguin's passion for painting took over. In the financial crash of 1882, he lost his job and despite having five children by then, he decided to become an artist.

Self-Portrait with Portrait of Émile Bernard (Les Misérables), *Paul Gauguin, 1888. As Japanese printmakers often exchanged work with each other, Vincent suggested that he, Gauguin and Bernard should do the same. Gauguin painted himself as Jean Valjean, the main character in Victor Hugo's* Les Misérables, *and wrote: 'By doing him with my features, you have my individual image, as well as a portrait of us all, poor victims of society.'*

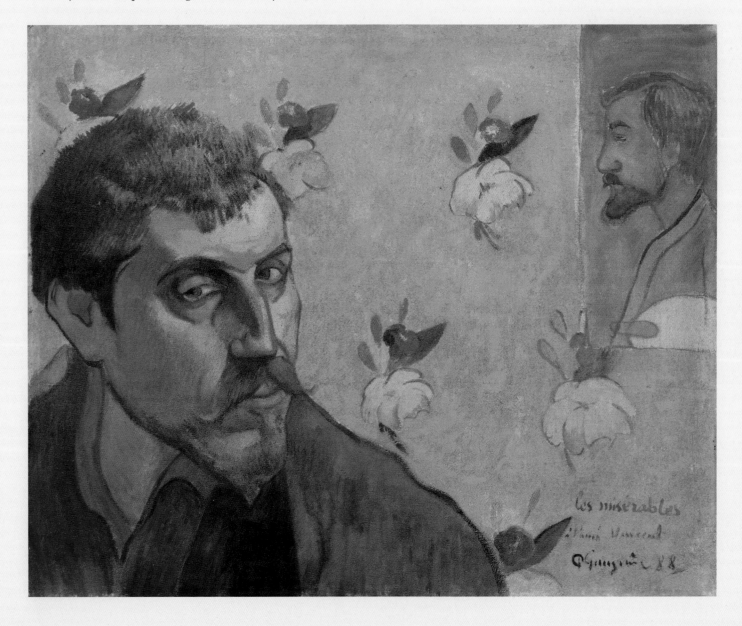

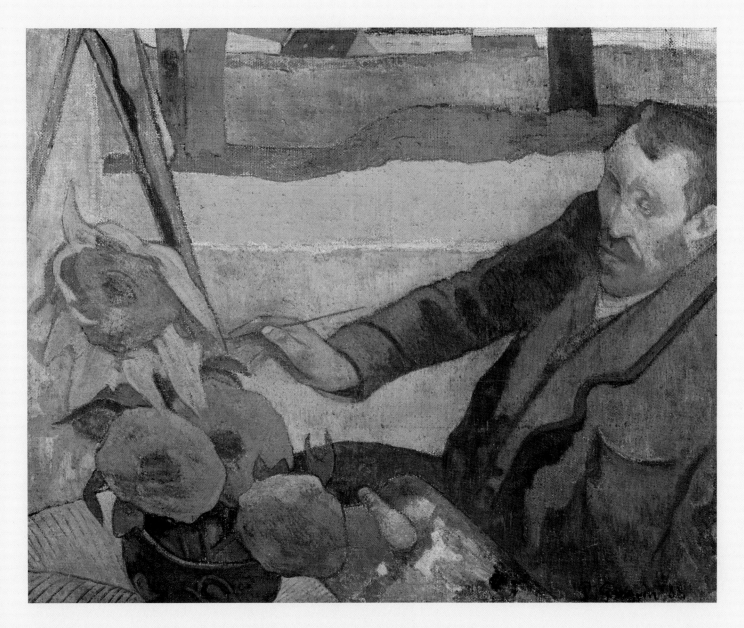

With her husband unable to support the family, Mette returned to Copenhagen with the children, and Gauguin carried on painting full-time. He experimented with woodcuts and ceramics and evolved a unique painting style of bold colours, reduced tonal contrasts and dark contours that had the effect of flattening his images and resembled stained glass or *cloisonné* enamelling. He gained admirers among younger artists, including Émile Bernard. In 1886, he spent five months in Pont-Aven in Brittany, painting with other artists there, including Bernard, and developing a new style which was inspired in part by Breton folk culture. In April 1887, he travelled to Panama and Martinique with the French artist Charles Laval, returning to Paris in November, when he met Vincent and Theo. One of the first artists to become influenced by African art, Gauguin was innovative, but during his life he had few followers. Theo exhibited his work in Paris and bought some of his paintings, but because of financial difficulties he was persuaded by Theo's generosity to join Vincent in Arles.

Vincent van Gogh Painting Sunflowers, *Paul Gauguin, 1888. Gauguin made this painting in December. Vincent's first impression on seeing it was that Gauguin had depicted him as a madman, but he later wrote: 'My face has lit up after all a lot since, but it was indeed me, extremely tired and charged with electricity as I was then.'*

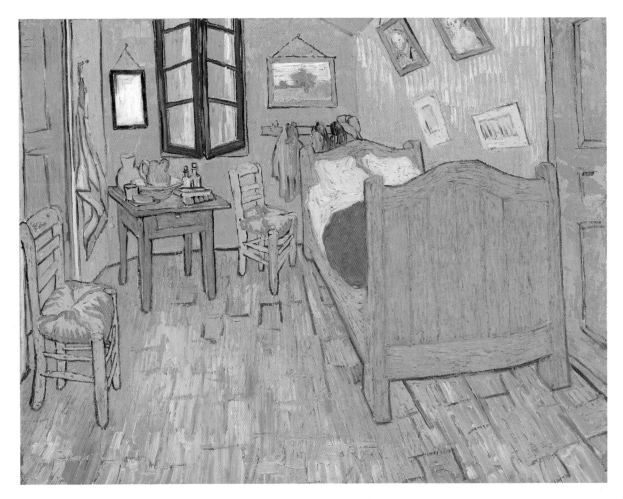

The Bedroom, 1889. *Vincent was so pleased with his painting of his bedroom that he made two further versions of it. He wrote to Theo describing it: 'In flat tints, but coarsely brushed in full impasto, the walls pale lilac, the floor in a broken and faded red, the chairs and the bed chrome yellow, the pillows and the sheet very pale lemon green, the bedspread blood-red, the dressing-table orange, the washbasin blue, the window green. I had wished to express utter repose.'*

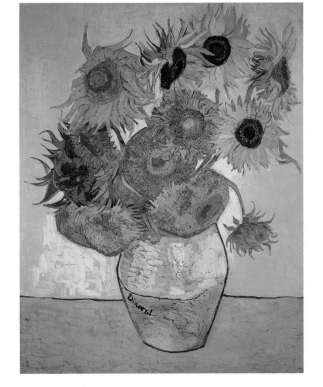

Sunflowers, 1888. *From August to September 1888, Vincent produced four paintings of sunflowers with compositions and colours inspired by Japanese prints and also the Cloisonnism of Bernard and Gauguin. He wrote to Theo: 'What I'm at is the painting of some sunflowers. If I carry out this idea there will be a dozen panels. So the whole thing will be a symphony in blue and yellow. I am working at it every morning from sunrise on, for the flowers fade so quickly.'*



LIVING TOGETHER

Gauguin arrived in Arles on 23 October. Initially, his presence calmed Vincent. He bought a chest of drawers and some kitchen utensils and cooked meals. He also showed Vincent how they could stretch their own canvases or use cheaper burlap that he had obtained. Together, they went out painting or stayed in and worked, but within a few days, they began to clash. Both had health problems and different attitudes to life and ideas about art. Soon their differences became apparent in almost every aspect of their lives. Gauguin preferred to paint predominantly from his imagination, while Vincent favoured painting direct observations. Horrified at how badly Vincent handled his money, Gauguin set up a regular system for bookkeeping, which irritated Vincent. Additionally, Gauguin charmed the local Arlésiennes and persuaded Marie Ginoux to pose for them.

INCREASING TENSIONS

Within a few weeks of Gauguin's arrival in Arles, Theo sent him 500 francs. He had sold one of his paintings. Theo wrote of Gauguin's '*grand succès*' in Paris, predicting that his reputation would be 'bigger than anybody had thought' and, perhaps most crushing for Vincent, that he 'could go the same way as Millet'. Vincent was hurt. He barely wrote to Theo and he and Gauguin argued more. Both were passionate, determined and stubborn. With frequent bad weather, they were often shut in the house together. Vincent worked frenetically, drinking and smoking excessively, and while he admired almost everything Gauguin produced, Gauguin was less complimentary about his work. Over nine weeks, Gauguin painted 17 canvases and Vincent about 25. Seeking to conform to Gauguin's ideas, Vincent began trying to paint more from his imagination, creating flatter-looking shapes and more sinuous lines.

In December, they visited the Musée Fabre in Montpellier, where they saw works by Courbet and Delacroix, but their relationship had begun to deteriorate. They often quarrelled; Gauguin became anxious to return to Paris and Vincent became increasingly fearful that he would. Gauguin wrote to Bernard: 'I'm in Arles, completely out of my element, because I find everything, the scenery and the people, so petty and shabby. Vincent and I rarely agree on anything, especially in painting.' Next, he wrote to Theo that 'Vincent and I absolutely cannot live side-by-side any longer without friction because of the incompatibility of our temperaments and because he and I both need tranquillity for our work.' Vincent's health began to worsen as his fear that Gauguin was going to leave became an obsession. He wrote to Theo: 'I believe that Gauguin is a bit disappointed in the good town of Arles, in the little yellow house where we are working, and especially in me.' Later Gauguin claimed that he often woke in the night to find Vincent standing over him, although Vincent never remembered this afterwards.

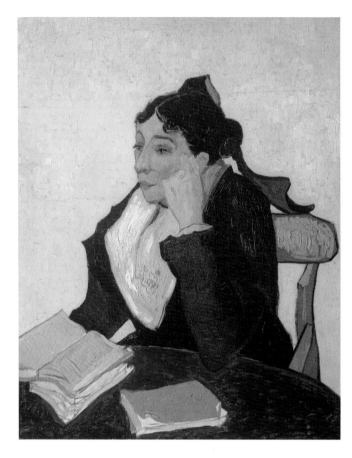

L'Arlésienne (Madame Ginoux), 1888–9. Marie Ginoux sat for Vincent and Gauguin in the Yellow House wearing her Arlésienne costume. Vincent immediately painted two portraits, following these several months later with yet more.

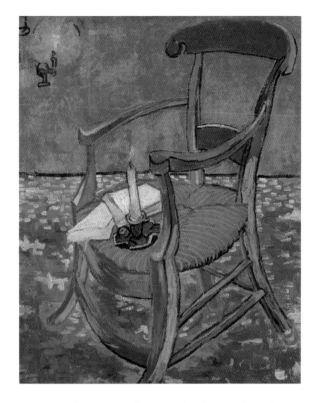

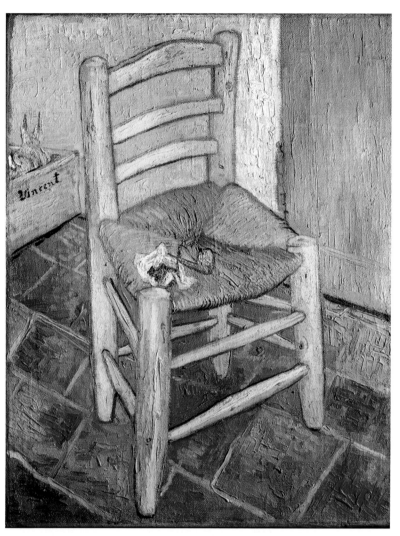

Gauguin's Chair, *1888 (above). Little is known about the two paintings made by Vincent of the chairs that he and Gauguin used in the Yellow House, but Gauguin's is painted at night, with novels and a burning candle.*

Vincent's Chair, *1888 (right). With Vincent's pipe and tobacco on his chair and two onions in a sprouting box in the background on the terracotta tiles, this painting is generally perceived as symbolizing hope and regeneration.*

Falling Leaves (Les Alyscamps), *1888. One of the first painting expeditions that Vincent and Gauguin undertook together was a visit to an ancient Roman necropolis, Les Alyscamps, just outside the medieval walls of Arles. Trying to follow Gauguin's methods, Vincent completed this in the studio during a period of bad weather.*

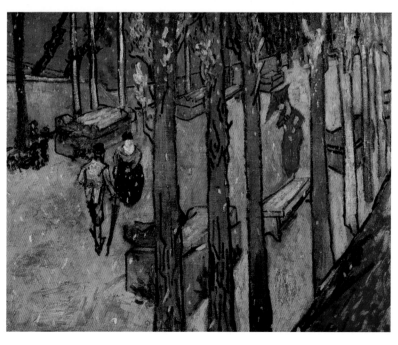

PORTRAITS

As much as he loved painting the landscape and sights in and around Arles, Vincent loved painting people even more. He wrote of portraiture: 'It is the only thing in painting that excites me to the depths of my soul, and which makes me feel the infinite more than anything else.' Models were not always forthcoming, but when someone did sit for him, he produced acute likenesses, projecting individual personalities in vibrant colours. Among those he produced there were members of the Roulin family, including Joseph Roulin, the local post-office worker, his wife Augustine and their three children, Armand, Camille and Marcelle. Joseph became a particularly loyal friend to Vincent, the family welcomed him, and he painted several portraits of them. He also painted portraits of a Zouave in uniform, a young woman in a red dress that he titled *La Mousmé*, a term for a young Japanese girl, and Eugène Boch, a Belgian painter whom he met and befriended in Arles.

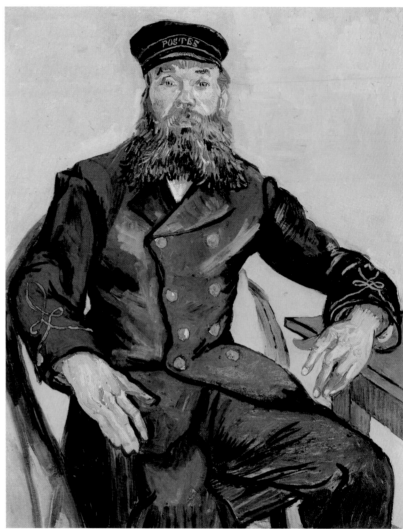

Portrait of the Postman Joseph Roulin, *1888. Vincent described his friend Joseph Roulin as 'such a good soul and so wise and so full of feeling and so trustful'. His appearance reminded Vincent of the Russian novelist Fyodor Dostoevsky, and he enjoyed painting his broad and friendly face. From 1888 to 1889, Vincent made at least six portraits of Roulin.*

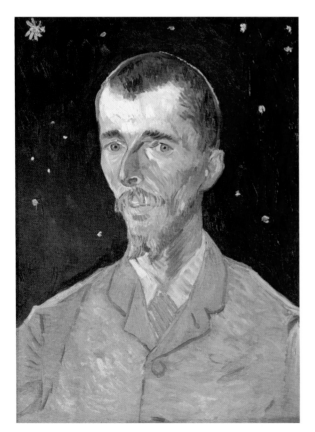

Portrait of Eugène Boch, *1888. Vincent met Eugène Boch in Arles in mid-June 1888. In July, he wrote to Theo: 'I very much like the looks of this young man with his distinctive face, like a razor blade, and his green eyes.' Later he also wrote of the painting: 'Behind his head ... I will paint infinity ... the richest blue ... and ... a mysterious effect.'*

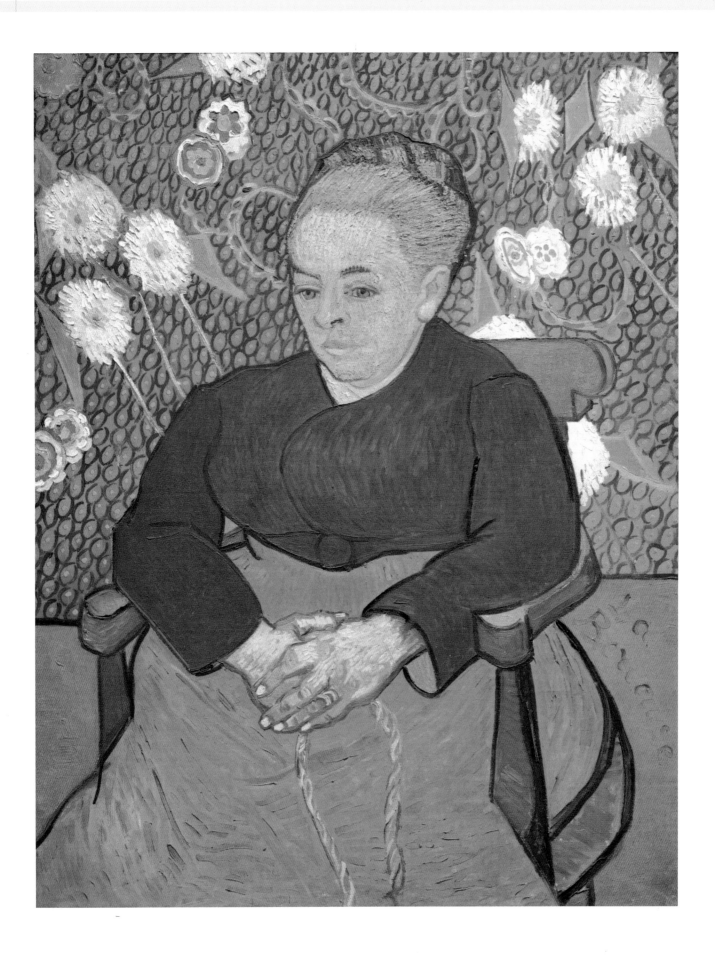

THE BREAKDOWN

Two months after Gauguin arrived in Arles, an incident occurred that has become not just one of the most famous aspects of Vincent's life but one of the most renowned events in the history of art. Yet the truth about what actually happened remains unclear.

Both men were in intense states of anxiety. Gauguin was preparing to leave, and this terrified Vincent. In addition, Christmas was always a difficult time for Vincent, and this year he had just heard of Theo's engagement to Johanna (Jo) Bonger, which meant that Theo would never come and stay with him now. Vincent imagined years of failure and loneliness ahead.

According to later accounts by Gauguin, on 23 December, Vincent asked him if he was planning to leave. When Gauguin said yes, Vincent tore off a piece of newspaper that read 'the murderer took flight' and handed it to Gauguin in silence. After supper, Gauguin went for a walk, but he had not gone far when he heard footsteps behind him. He wrote: 'I turned at the very moment when Vincent rushed at me with an open razor in his hand. My look must at that moment have been very powerful, because he stopped, and lowering his head he ran back in the direction of the house.' Gauguin booked into a hotel for the night.

The most accepted theory is that Vincent returned alone to the Yellow House, anxious, ill and probably drunk. He felt a failure, and despairing, he sliced off his left ear with the razor, severing an artery. For many years, it has been accepted that he sliced off only part of his earlobe, but the recent discovery of a doctor's letter (see page 77) confirms that it was in fact his entire ear. He managed to bind his head, wrapped up the severed ear in a piece of newspaper, and made his way to a local brothel where he gave it to a prostitute named Rachel. Then he stumbled back to the Yellow House and collapsed.

A week later, the incident was reported in the newspaper *Le Forum Républicain*: 'Last Sunday, at half past eleven in the evening, one Vincent van Gogh, a painter and native of Holland, presented himself at brothel no 1, asked for one Rachel, and handed her … his ear, telling her: 'Keep this object carefully.' Then he disappeared. Informed of this act, which could only be that of a poor lunatic, the police went the following day to the home of this individual, whom they found lying in his bed, by then showing hardly any sign of life. The unfortunate was admitted to the hospital as a matter of urgency.'

Lullaby: Madame Augustine Roulin Rocking a Cradle (La Berceuse), *1889.*
Against a vividly patterned background, this is Augustine Roulin, rocking her baby's cradle (out of the picture frame) with a rope. Augustine was one of the few women in Arles who welcomed Vincent into her home.

SELF-PORTRAITS

Because so few models would sit for Vincent, and he had little money to pay them anyway, he frequently used himself as a model as he developed his own unique ways of working. Over ten years, Vincent produced at least 39 self-portraits, both drawings and paintings. In September 1889, he wrote to Theo: 'They say – and I am very willing to believe it – that it is difficult to know oneself – but it isn't easy to paint oneself either. So I am working on two self-portraits at the moment – for want of another model ... In the one I began the first day I got up, I was thin and deathly pale. It is dark purple-blue, and the head whitish with yellow hair, thus with a colour effect. But I have since started another, three-quarter profile on a light background.'

At the time, few artists painted self-portraits. In the seventeenth century, Rembrandt had been unique in painting so many. Like Rembrandt, Vincent's self-portraits demonstrate his changing appearance and his evolving palette and painting methods. They show his development as an artist and also depict his emotions at various points in his life. Most were produced while he was in Paris and demonstrate his experimentation with colour, brushmarks, composition and light. They include pointillist attempts, agitated dashes and slabs, and short, cursive marks. The compositions are influenced by Rembrandt, with most in the classic three-quarter view of head and upper torso. As time passed they became exceptionally expressively painted.

Self-Portrait, 1886. One of Vincent's earliest known self-portraits, this was painted in a single session when he first arrived in Paris, showing his early brushwork, dark palette and thick but blended marks with strong tonal contrasts.

Self-Portrait as a Painter, 1887–8. Holding a palette and paintbrushes and standing behind his easel, Vincent uses the ideas of some of the artists he met in Paris, barely blending his paint. Colours are placed next to their complementaries, intensifying them. He wrote to Wil that he had portrayed himself with 'wrinkles in forehead and around the mouth, stiffly wooden, a very red beard, quite unkempt and sad'.

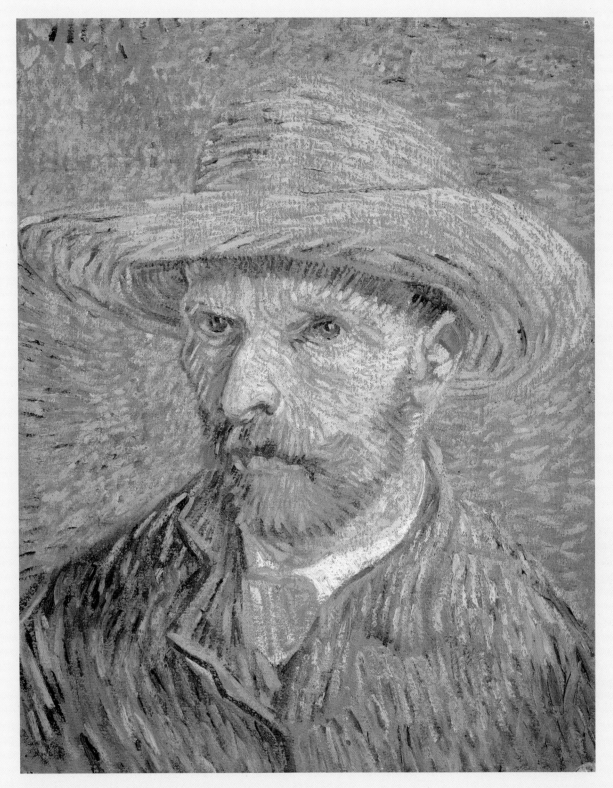

Self-Portrait with a Straw Hat, 1887. While in Paris, Vincent produced more than 20 self-portraits. 'I purposely bought a good enough mirror to work from myself, for want of a model,' he wrote. Painted on the back of an earlier peasant study, this self-portrait shows his awareness of Neo-Impressionist techniques and colour theory and demonstrates his use of flat, angled brushstrokes and juxtaposition of colours.

After he moved to Arles, Vincent's palette and brushwork became even brighter and more intense. He began to assimilate his influences, including Rembrandt, Millet, Corot, Rubens, Mauve, Monticelli, Delacroix, Seurat, Japanese ukiyo-e art, Gauguin and of course the warm, bright light of the sun.

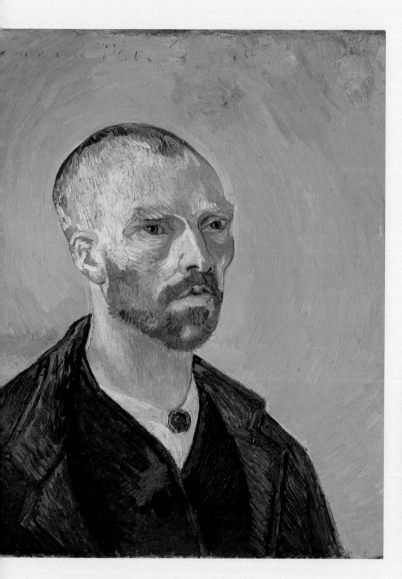

Self-Portrait Dedicated to Paul Gauguin, *1888.*

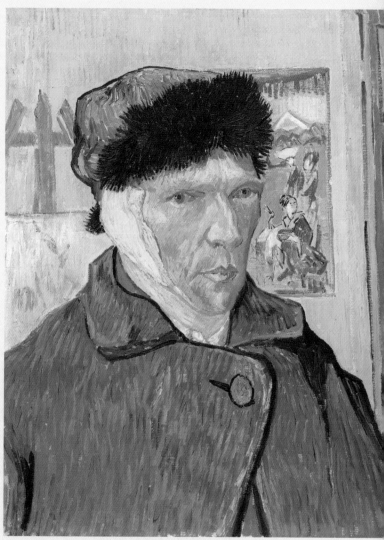

Self-Portrait with Bandaged Ear, *1889.*

These two works reveal how much Vincent developed in such a short time. Painted in Arles, both show influences of the Impressionists, Neo-Impressionists and Japanese art, but also Vincent's growing confidence and skills.

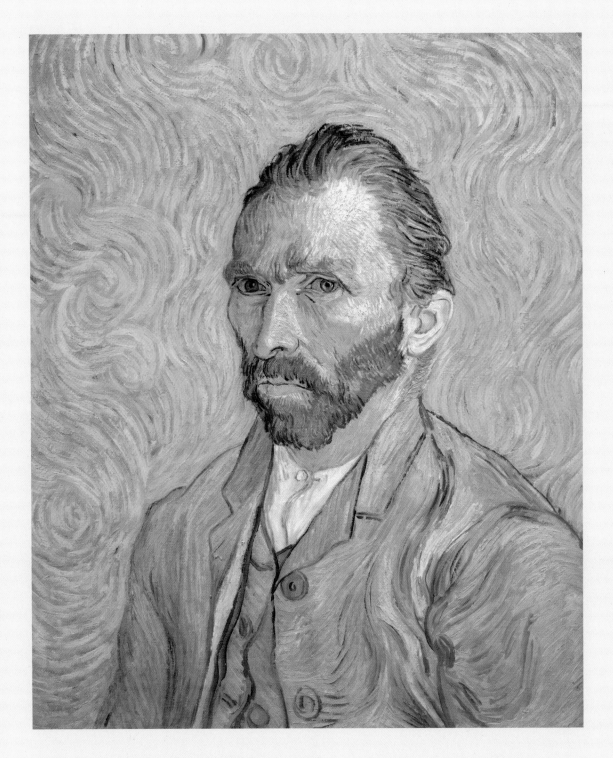

After Vincent had mutilated himself, he continued producing three-quarter-view self-portraits, but from the right side rather than the left. By this time, he had moved to the asylum at Saint-Rémy and was using a lighter palette and more skilful, cursive brushmarks. Hollow-cheeked, with a look of anguish in his eyes, he had developed a self-assured approach.

Self-Portrait, 1889. By this time, Vincent was extremely accomplished in the handling of paint, his understanding of light and ways of conveying his underlying torment and vulnerability. The pervading colours of blues, greens and violets convey his mood, but also create vibrancy as they are complementaries of his skin and reddish hair. Additionally, the rhythmical, flowing strokes create a sense of dynamism and luminosity.

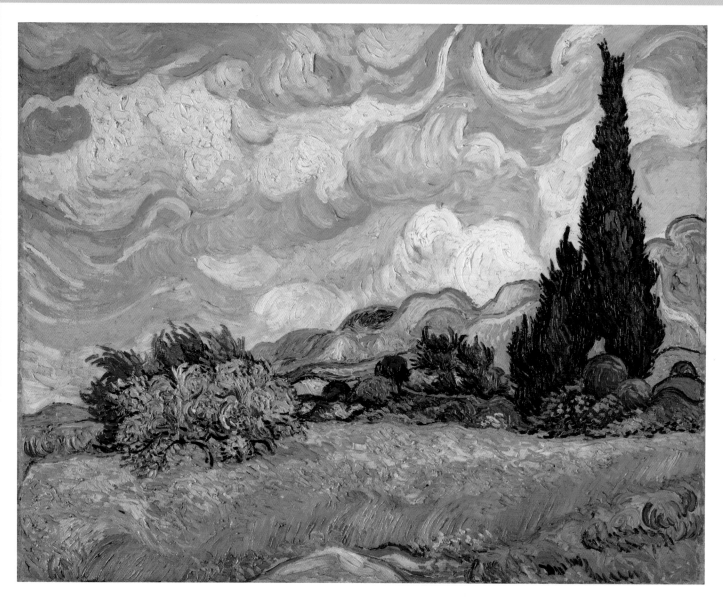

Wheatfield with Cypresses, 1889. *Vincent painted this while in the asylum at Saint-Rémy, writing to Theo: 'I have a canvas of cypresses with some ears of wheat, some poppies, a blue sky like a piece of Scotch plaid; the former painted with a thick impasto like the Monticellis, and the wheatfield in the sun, which represents the extreme heat.'*

CHAPTER 5
Saint-Rémy and Auvers-sur-Oise

On 24 December 1888, Gauguin returned to the Yellow House, where a crowd had gathered outside. The police had found Vincent on his bed. He was taken to the hospital in Arles and Gauguin asked the police to tell Vincent that he had returned to Paris, as 'the sight of me could be fatal to him'. He then sent a telegram to Theo, urging him to come immediately. In Paris, Theo had been celebrating his engagement, but on receipt of Gauguin's telegram, he took a train to Arles, arriving on Christmas morning 1888.

Dr Félix Rey, who was treating Vincent, diagnosed 'acute mania with generalized delirium' and also 'a kind of epilepsy', which was the usual term for psychiatric disorders at the time. After seeing Vincent, Theo wrote to Jo: 'For the past few days he had been showing symptoms of that most dreadful illness, of madness, and an attack of *fièvre chaude*, when he injured himself with a knife, was the reason he was taken to hospital. Will he remain insane? The doctors think it possible, but daren't yet say for certain … It was terribly sad being there, because from time to time all his grief would well up inside and he would try to weep, but couldn't. Poor fighter and poor, poor sufferer.'

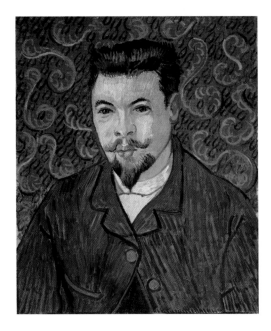

Portrait of Dr Félix Rey, 1889. *While recovering in hospital, Vincent became friendly with Dr Félix Rey. On the day of his discharge, Dr Rey visited Vincent, and several weeks later, Vincent painted this portrait of him as a thank you gift.*

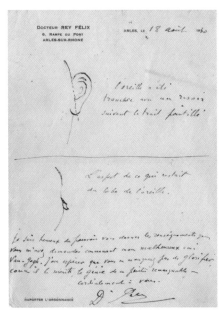

Drawing by Dr Félix Rey of the mutilation of Vincent van Gogh's ear, 18 August 1930. *This recently discovered sheet with diagrams and notes made by Dr Rey shows that Vincent cut off his entire ear. Dr Rey drew it in 1930 for the author Irving Stone, who was writing a novel about Vincent's life. Next to the drawing, Rey wrote: 'The ear was cut off with a razor as shown by the dotted line.'*

TEMPORARY RECOVERY

Theo returned to Paris with Gauguin on Boxing Day 1888. Although they continued to correspond, Vincent never saw Gauguin again. Meanwhile, Vincent seemed to recover and he was discharged from hospital on 7 January. Dr Rey visited him at the Yellow House, as did Reverend Frédéric Salles, a Protestant pastor, who had befriended him soon after he moved to Arles. He sent Theo regular updates about Vincent's health. A month after he had arrived home, however, Vincent was readmitted to hospital and, as before, placed in isolation. When he felt well he painted. Sometimes he went into town, for instance with Signac when he visited. Signac wrote to Theo in March 1889: 'I found your brother in a perfect state of physical and mental health. We went out together yesterday afternoon and again this morning. He took me to see his paintings, of which many are very good and all of them very intriguing. His kind doctor, the house physician Rey, believes that if he had a very methodical life, eating and drinking normally and at regular times, there would be every chance that his terrible crises would not be repeated.' Meanwhile, many inhabitants of Arles signed a petition stating that as a dangerous madman Vincent should not be at liberty.

Garden of the Hospital in Arles, *1889. This was Vincent's view of the courtyard of the hospital in Arles from his window. Using dramatic perspective, he contrasts green with bold yellow and a few touches of other bright colours, conveying an optimistic mood.*

Still Life with a Plate of Onions, 1889. *On the day he was discharged from hospital, Vincent painted two still lifes, to 'get used to painting again'. With expressive brushwork, he painted just what was in front of him, including a letter from Theo, a plate of onions, a pipe, a coffee pot and a book about nutrition and hygiene.*

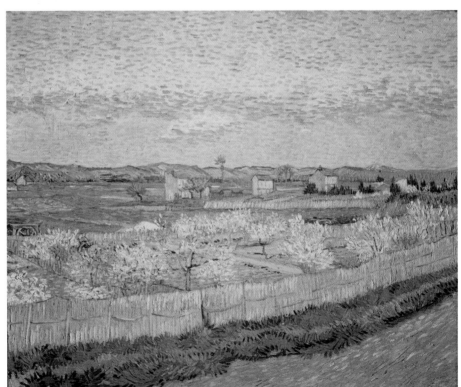

Peach Trees in Blossom, 1889. *Vincent wrote to Theo: 'I am well just now, except for a certain undercurrent of vague sadness difficult to define – but anyway – I have rather gained than lost in physical strength, and I am working. Just now I have on the easel an orchard of peach trees beside a road with the Alpilles in the background.'*

SAINT-RÉMY

Because of his neighbours' hostility, Vincent could not return to the Yellow House. Reverend Salles suggested that he voluntarily enter the asylum of Saint-Paul-de-Mausole at Saint-Rémy, and Theo agreed. Joseph-Michel and Marie Ginoux stored his furniture in the Café de la Gare, and, funded by Theo, he admitted himself to the asylum in the foothills of the Alpilles. On 2 May, he sent Theo two cases of paintings, writing: 'As a painter, I shall never amount to anything important now, I am absolutely sure of it.' He settled into two rooms, one a bedroom, the other a studio. He wrote to Theo: 'Through the iron-barred window I can make out a square of wheat in an enclosure. What a beautiful land and what beautiful blue and what a sun!'

Saint-Paul-de-Mausole had originally been a monastery, but had been used as an institution for the mentally ill since the seventeenth century. A former naval physician, Doctor Théophile Peyron, cared for Vincent, and believed that he was the victim of epileptic seizures. The relative isolation of the asylum, a diet of mainly lentils and beans, lack of alcohol, cold baths and quiet reading helped Vincent's

Irises, 1889. *Within the first week of his arrival at Saint-Rémy, Vincent painted the irises in the asylum's garden. The angular, cropped composition, brilliant colour and sense of movement were influenced by Japanese ukiyo-e art. Vincent perceived it as a study, but later that year, Theo submitted it to the Salon des Indépendants in Paris, describing to Vincent how it looked: '[It] strikes the eye from afar. It is a beautiful study full of air and life.'*

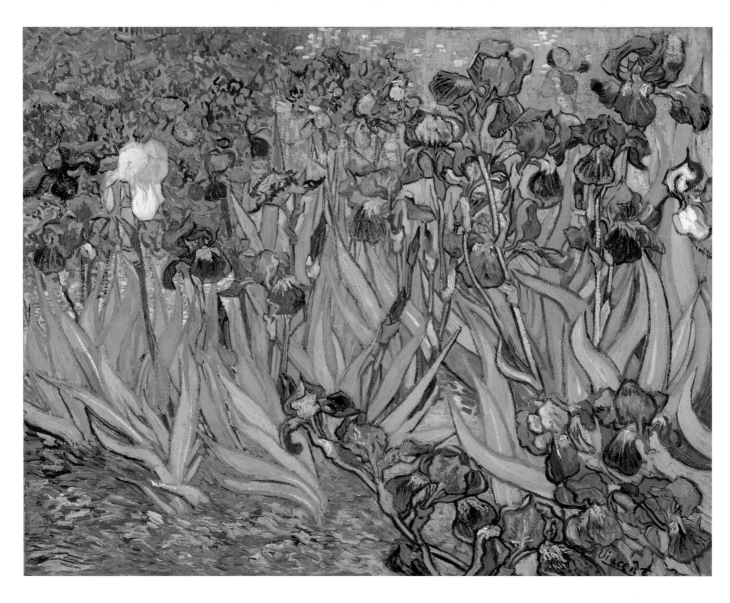

recovery. On his lucid days, he drew and painted in the walled garden of the asylum and even beyond it if accompanied by a hospital orderly, and he also copied prints of paintings by artists such as Rembrandt and Millet. During a period of extreme confusion, he ate some of his oil paint, and so for a while he was restricted to drawing only. Nonetheless, he was extremely productive over the year he was there, and completed approximately 150 paintings.

In April 1889, Theo and Jo had married in Amsterdam and the following January, they had a son whom they named after Vincent: Vincent Willem van Gogh. Vincent sent the baby a painting, *Almond Blossom*, and wrote to his mother: 'I'd much rather that he'd called his boy after Pa, whom I've thought about so often these days, than after me, but anyway, as it's been done now I started right away to make a painting for him, to hang in their bedroom. Large branches of white almond blossom against a blue sky.'

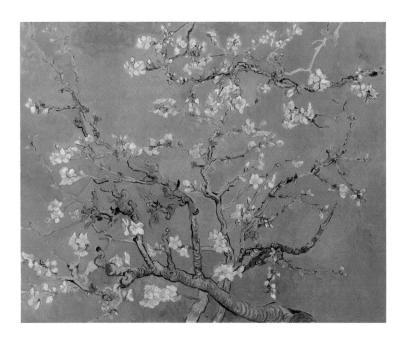

Almond Blossom, *1890. On 31 January 1890, Vincent's nephew and godson was born. Vincent painted these blossoming almond branches against a blue sky as his first gift to the baby. He said that the tree symbolized his namesake's birth.*

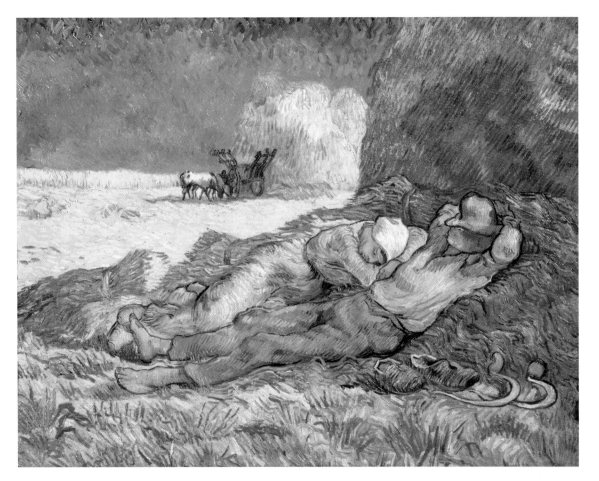

Noon: Rest from Work *or* The Siesta (after Millet), *1890. Painted while Vincent was at Saint-Rémy, this is a copy of a pastel drawing by Millet. Vincent considered Millet to be 'a more modern painter than Manet' and interpreted many works by Millet in his own style.*

VINCENT'S ILLNESS

In the late nineteenth century, little was known about psychiatric disorders or how to treat them, and although thousands of medical papers have been written about Vincent's health, there has never been a conclusive diagnosis. Suggestions have included lead or absinthe poisoning, bipolar disorder, epilepsy, syphilis, schizophrenia, Ménière's disease (of the inner ear) and acute intermittent porphyria (a metabolic disorder). His episodes of depression followed by sustained periods of increasingly high energy and enthusiasm do suggest bipolar disorder, which is characterized by manic and depressive episodes, including reckless behaviour, euphoria and impulsiveness. After the crisis of 23 December 1888, his attacks became more frequent, and his initial confusion and loss of consciousness were followed by periods of stupor and incoherence, during which he was generally unable to paint, draw or write letters.

Among the most frequent complaints in his letters are those about his digestion, but he also suffered from hallucinations, nightmares and insomnia, and often reported that he had a fever. Before his diagnosis of gonorrhoea in 1882, he was unable to sleep for three weeks. He also probably had some hereditary problems; his younger brother Cor committed suicide and his sister Wil spent almost 40 years in a mental asylum. After his arrival in Arles, he wrote: 'I was surely about to suffer a stroke when I left Paris. It affected me quite a bit when I had stopped drinking and smoking so much, and as I began to think instead of knocking the thoughts from my head. Good heavens, what despair and how much fatigue I felt at that time.' Yet he soon resumed his former habits of drinking absinthe and cognac. When first in hospital in

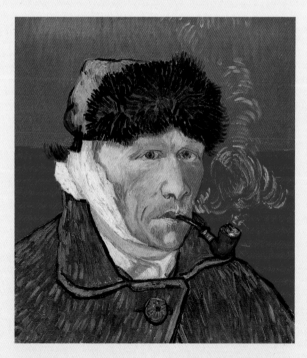

Self-Portrait with Bandaged Ear and Pipe, 1889. *Painted soon after Vincent returned home from hospital, this self-portrait features the prominent bandage around his head and his tormented expression, conveyed through bright colours, impasto paint, heavy outlines and visible brushmarks.*

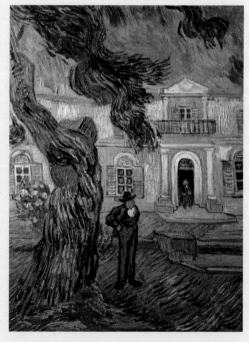

Saint Paul's Hospital in Saint-Rémy-de-Provence, 1889. *Vincent began to recover at the asylum. He found the other patients 'more discreet and polite' than the hostile people of Arles, and his time there was exceptionally productive.*

Arles, he wrote: 'I am unable to describe exactly what is the matter with me; now and then there are horrible fits of anxiety, apparently without cause, or otherwise a feeling of emptiness and fatigue in the head … and at times I have attacks of melancholy and of atrocious remorse.'

The Starry Night, 1889. *Vincent wrote to Theo: 'This morning I saw the countryside from my window a long time before sunrise, with nothing but the morning star, which looked very big.' The swirling marks and vibrant colours of this painting are a blend of his observations and his imagination.*

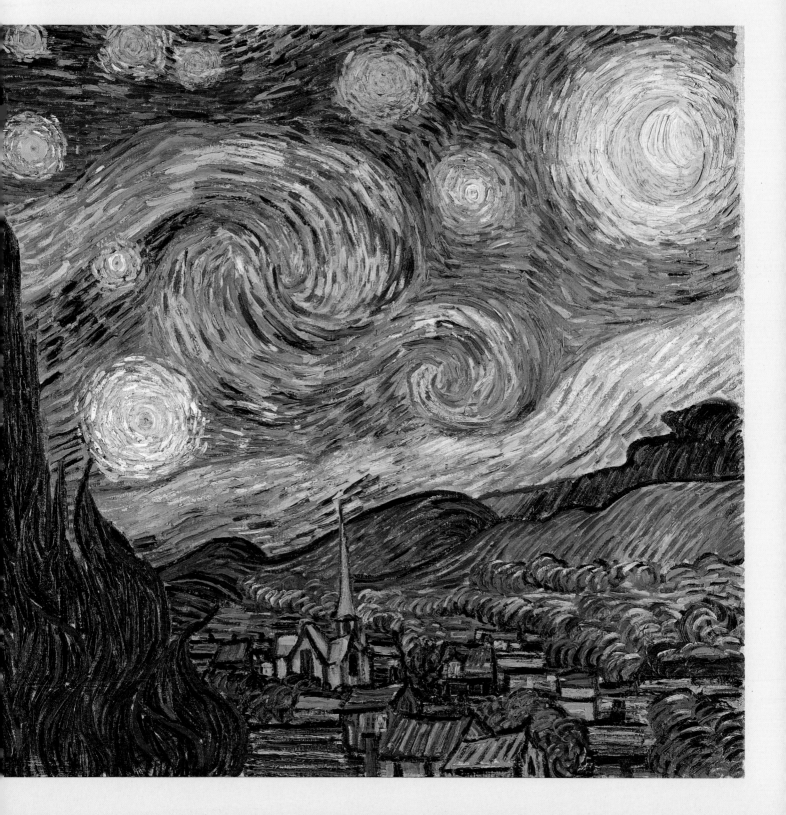

The Red Vineyard, *1888. Painted on a piece of Gauguin's burlap in early November 1888, this is the only painting that was officially recorded as sold during Vincent's lifetime. He almost certainly sold more than this. For instance, his first commission of cityscapes of The Hague came from his art dealer uncle Cor. He sometimes traded his paintings for food or art supplies and Père Tanguy probably bought at least one. In a letter he wrote that he had sold a portrait to someone – although neither the work nor the buyer are known – and Theo sold another of his paintings to a London gallery.*

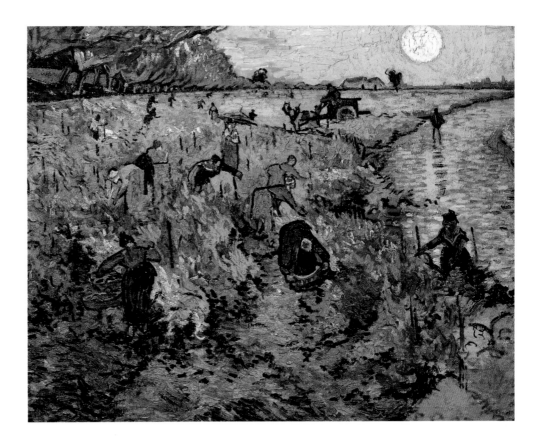

EXHIBITIONS AND ARTICLES

Since 1888, Theo had submitted Vincent's paintings to the annual Salon des Indépendants and in March 1890, ten of his paintings were selected for that year's show. Theo wrote to him: 'How pleased I would have been if you'd been there at the Independents' exhibition ... Your paintings are well placed and look very well. Many people came up to ask me to give you their compliments. Gauguin said that your paintings are the key to the exhibition.' Also early in 1890, six of his paintings were shown in Brussels at a group exhibition of the Belgian artists' association 'Les Vingt' (The Twenty), and one of the exhibited paintings, *The Red Vineyard*, was sold during the show for 400 francs, to Anna Boch, a Belgian artist and art collector and the sister of his friend Eugène.

In January 1890, the art critic and painter Albert Aurier wrote a review, *Les Isolés: Vincent van Gogh*, in the magazine *Mercure de France*, plus an abridged version in the magazine *L'Art moderne*. Aurier aligned Vincent's art with the nascent Symbolist movement and commented on the 'originality and intensity of his artistic vision', writing that he was the only painter he knew 'who perceives the colouration of things with such intensity, with such a metallic, gem-like quality'. Always self-deprecating, Vincent wrote to Aurier: 'Thank you very much for your article in the *Mercure de France*, which greatly surprised me. I like it very much as a work of art in itself, I feel that you create colours with your words; anyway, I rediscover my canvases in your article, but better than they really are – richer, more significant ... However, I feel ill at ease when I reflect that what you say should be applied to others rather than to me.'

AUVERS-SUR-OISE

After 14 months at Saint Paul's asylum, Vincent left on 17 May 1890 and met Theo at the Gare de Lyon in Paris. He stayed with Theo and Jo for a night and met baby Vincent for the first time, then he travelled to Auvers-sur-Oise, about an hour's train journey from Paris. Theo had suggested that Vincent would do well in the little village; it was not too far from his brother and there he could be under the care of Dr Paul Gachet. Gachet was an experienced doctor and also a painter and a friend of many artists, some of whom had lived in or near Auvers, including Cézanne and Pissarro. In 1854, Corot and Daubigny had painted together in the village.

With its church, thatched cottages and undulating fields, the peaceful, picturesque village fascinated Vincent. He wrote to Theo: 'There are many private homes and modern, middle-class dwellings which are very pleasant, sunny and filled with flowers. And this in a countryside that is almost plump. Right at present the development of a new society amidst the old is not at all disagreeable. There's quite an aura of well-being … no factories, only beautiful greenery, abundant and well-kept.' Vincent rented a room in Auberge Ravoux and regularly visited his new friend Dr Gachet. He began painting immediately, often *en plein air*, and in just two months he produced approximately 70 paintings, as well as a large number of drawings.

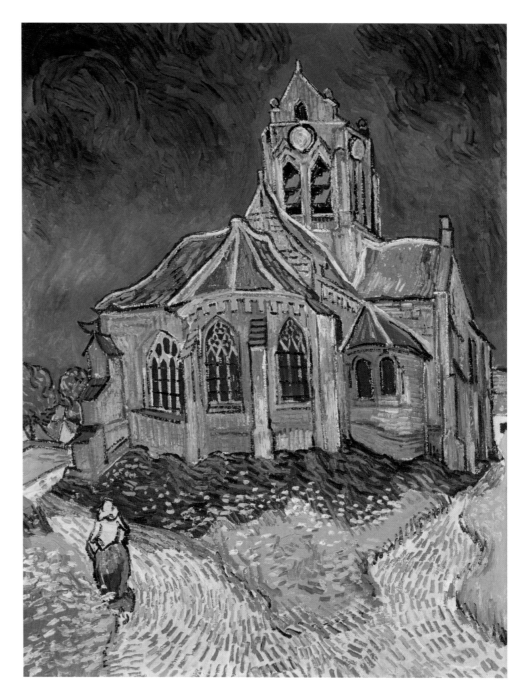

The Church at Auvers-sur-Oise, 1890. *Vibrant, fluid, colourful and with energetic marks, this is one of the many paintings that Vincent produced during his time in Auvers. The thirteenth-century church was a short walk away from where he was staying.*

DR GACHET

A widower with two teenage children, Dr Paul Gachet was a physician, interested in homeopathy, and an amateur painter. He also suffered with depression and he advised Vincent to cut back on smoking and alcohol, but Vincent ignored that. The two men had lunch together twice a week, but with little available to treat Vincent at that time, Dr Gachet's treatment was quite ineffectual. In July 1890, Vincent wrote to Theo: 'I think that we must not count on Dr Gachet at all. First of all, he is sicker than I am, I think, or shall we say just as much, so that's that. Now when one blind man leads another blind man, don't they both fall into the ditch?' Passionate about art, Dr Gachet also had a considerable collection of paintings, including works by Pissarro, Cézanne, Renoir and Monticelli that had inspired Vincent. He painted two portraits of the doctor, in both of them leaning on his elbow and holding the medicinal herb foxglove.

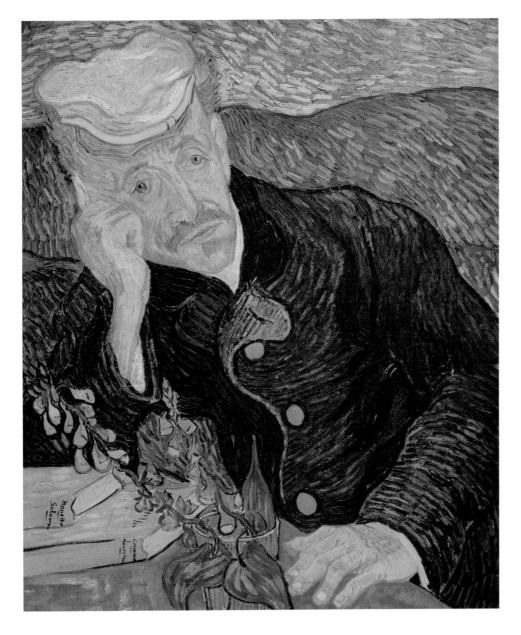

Portrait of Dr Paul Gachet, *1890. The first of two portraits Vincent produced of Dr Gachet, this fluidly painted work features strong colours in the red table, two yellow books, the blue jacket, beige cap and the purple foxglove.*

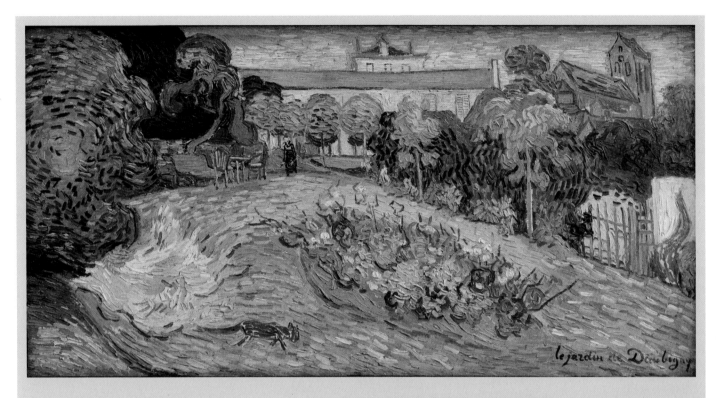

Daubigny's Garden, 1890. After painting Daubigny's walled garden, Vincent wrote to Theo: 'Perhaps you'll take a look at this sketch of Daubigny's garden – it is one of my most carefully thought-out canvases.'

CHARLES-FRANÇOIS DAUBIGNY

Born in Paris to a family of painters, Charles-François Daubigny initially painted in a traditional rather academic style, but after 1843 when he settled in Barbizon and met Corot and Courbet, his approach changed. He turned his boat, *Botin*, into a studio and painted *en plein air* along the rivers Seine and Oise. In 1860, he bought land in Auvers, where he had been painting since the 1850s, and built a long, narrow house there, painted pink and with a surrounding garden.

Daubigny often advised and promoted other artists, including Renoir and Pissarro when they were denied admission to the Salon in 1866 and 1867 respectively. In 1866, he visited England and stayed there, returning four years later in 1870 because of the Franco-Prussian War. Back in Auvers, he met Cézanne, and advised him on technique and painting approaches as they both painted in and around the village.

One of the first artists to capture transient moments, Daubigny became highly influential to the Impressionists and Post-Impressionists with his technique of *plein air* painting. Vincent revered him, and from May to July 1890, he painted Daubigny's garden three times. He began with a small study of a section of it and then executed two large-scale canvases of it in its entirety.

DEATH

In Auvers, Vincent painted the surroundings frenziedly, completing approximately one painting a day. At the end of June 1890, Theo wrote to him: 'We have gone through a period of the greatest anxiety; our dear little boy has been very ill …' In the same letter, he wrote: 'At present we do not know what we ought to do; there are problems … Ought I to live without a thought for the morrow, and when I work all day long not earn enough to protect that good Jo from worries over money matters, as those rats Boussod and Valadon are treating me as though I just entered their business, and are keeping me on a short allowance?' He was facing difficulties in his job and wanted to leave, to work for himself as an art dealer, and he told Vincent that he would not be able to continue sending him money on a regular basis. Vincent's guilt and shame about being a burden on his brother came to the fore once more. He realized that Theo needed all his money to support his family and to begin his new venture as an independent art dealer. He rushed to Paris, but argued with Jo and left in as much haste as he had arrived, later writing to Theo: 'I feared that being a burden to you, you felt me to be rather a thing to be dreaded.'

On Sunday 27 July 1890, Vincent took his painting equipment and went off to the fields. That evening, he was found by members of the Ravoux family in his room with a bullet in his stomach. He showed them the small hole under his ribs and said: 'I wounded myself.' They immediately fetched Dr Gachet. Vincent seemed comfortable and there was little blood. No attempt was made to remove the bullet nor take him to hospital, and he would not reveal Theo's address. As it was a Sunday, Theo was not at work, so he could not be found that way, but the next day, he was contacted and by midday he was sitting at Vincent's bedside. Vincent was sitting up, smoking his pipe, and they talked in Dutch together. He seemed fairly calm. Then the pain increased and he became delirious. At 1 am on 29 July 1890, he died

in Theo's arms, and the following day was buried in Auvers churchyard. He left more than 850 paintings and almost 1,300 works on paper. No evidence of what happened on the day of the shooting has ever come to light. Vincent's painting equipment and the gun from which the bullet was fired were never found. Six weeks after his death, Theo organized a memorial exhibition of his work. He resigned from Boussod and Valadon, and his grief consumed him. His already delicate health suffered, and Jo took him to Utrecht where he died in an asylum on 25 January 1891, barely six months after Vincent.

Wheatfield with Crows, 1890. *Painted in July, this is the wheatfield behind the Auberge Ravoux. It is a direct view, despite the myths that have grown up around the symbolism of the converging paths, the lowering sky and the crows. Vincent wrote to Theo: 'They're immense stretches of wheatfields under turbulent skies, and I made a point of trying to express sadness, extreme loneliness ... these canvases will tell you what I can't say in words, what I consider healthy and fortifying about the countryside.'*

EPILOGUE: VINCENT'S LEGACY

Almost from the moment he died, Vincent's reputation began rising. Jo, Theo's widow, who had inherited his art with her baby son, sought to raise public awareness of it in various ways. She cultivated a critical following, inspiring the interest of collectors, museums, critics and the public and she sent his paintings to numerous exhibitions, but she refused to publish his letters before his art was well known, realizing that the story of his tragic life might deflect attention from the works themselves. The letters were finally published in 1914, in the same year that she had Theo re-interred in Auvers, in a grave next to Vincent's.

Meanwhile, in 1893, Bernard published the letters that Vincent had written to him. In 1895 and again in 1896–7, the art dealer Ambroise Vollard organized two exhibitions of Vincent's work in Paris. It was the first time the public were able to see so many of his paintings at once, and it was probably through Vollard that Pablo Picasso first encountered Vincent's art. Like so many others, Picasso was instantly inspired. In 1901, the newly opened Bernheim-Jeune Gallery in Paris held a retrospective of Vincent's work that was seen by artists including Henri Matisse, André Derain and Maurice de Vlaminck, who later became known as Fauves (Wild Beasts) for their colourful, dynamic paintings that were directly inspired by Vincent. Soon his work was being exhibited beyond France, such as in 1905 in the Galerie Arnold in Dresden, generating excitement among the artists of Die Brücke (The Bridge), the first Expressionist group that had been founded just a few months before. Seeing him as the greatest genius of modern art, they considered themselves to be Vincent's heirs.

Vincent's work continued to inspire artists such as Wassily Kandinsky and Franz Marc, who along with some others in Munich started the innovative Expressionist group Der Blaue Reiter (The Blue Rider) and although they never met, Edvard Munch, one of his contemporaries, became extremely affected by Vincent's 'passion' and 'fire of the soul'. His influence does not diminish. Since his death, artists and the public across the globe have unceasingly been engaged with and motivated by Vincent's unique style of art. The drawings and paintings he left remain a testament to the power and universality of art.

Interior at Collioure, *Henri Matisse, 1905. Matisse was overwhelmed by the colourful exuberance and expression of Vincent's painting. After seeing his work in Paris in 1901, Matisse changed his style, brightening his palette and exaggerating and distorting, using expressive brushmarks and heavy lines to convey vitality and emotion.*

TIMELINE

1850s

'53 Vincent is born on 30 March in Groot Zundert in the Netherlands, to Protestant pastor Theodorus van Gogh and his wife Anna Cornelia van Gogh.

'57 Theodorus (Theo) van Gogh is born on 1 May.

1860s

'64 At the age of 11, Vincent is sent to boarding school in Zevenbergen.

'69 Vincent starts working in The Hague for the art dealer Goupil & Cie, which was founded originally by his Uncle Cent.

1870s

'72 Vincent and Theo begin their lifelong correspondence.

'73 Vincent is transferred to the London office of Goupil, and Theo joins the Brussels branch. Vincent falls in love with the daughter of his landlady and her rejection of him precipitates a personal crisis.

'75 Vincent is transferred to the Parisian branch of Goupil. There, he visits museums and galleries, and neglects his work. He spends Christmas with his parents in Etten without permission from his employers.

'76 While Theo is transferred to the Goupil office in The Hague, Vincent is dismissed and takes a teaching post at a boarding school in Ramsgate, England, from mid-April until July. He then moves to a post in Isleworth on the outskirts of London, where he is also allowed to preach occasionally. In December, he returns to his family in Etten.

'77 From January to April, Vincent works as a book clerk in Dordrecht. From May, he stays in Amsterdam with his uncle Jan van Gogh, while preparing to take university entrance exams for studies in theology.

1870s continued

'78 In July, Vincent gives up his studies and returns to Etten. Then he takes a probationary course at an evangelical college near Brussels, but is not accepted for the job of lay preacher.

'79 Working as a lay preacher in the coal-mining district of the Borinage region in Belgium, Vincent gives his clothes and belongings to the poor.

1880s

'80 Vincent travels to Cuesmes, where he lives with a mining family. He decides to become an artist, then moves to Brussels to study perspective and anatomy. Theo supports him financially.

'81 In April, Vincent leaves Brussels to live in Etten, and falls in love with his widowed cousin Kee Vos-Stricker, who spurns him. He quarrels with his family and around Christmas leaves for The Hague.

'82 In The Hague, a cousin by marriage, Anton Mauve, gives Vincent painting lessons and lends him money. He lives with alcoholic prostitute Clasina Maria Hoornik (Sien) and her two children. Uncle Cornelis commissions him to make 19 pen and ink drawings.

'83 In September, Vincent leaves The Hague and works alone in Drenthe. In December, he returns to the family home at Nuenen.

'84 When his mother breaks her leg, Vincent cares for her. He begins using watercolours and makes studies of weavers. He also reads Delacroix's theories on colour. Theo joins Goupil in Paris.

1880s continued

'85 In March, Theodorus dies and after his sister Anna accuses Vincent of killing their father, he moves into his studio in the sexton's house. He paints *The Potato Eaters*. In November, he moves to Antwerp, where he buys his first Japanese prints.

'86 From January to the end of February, Vincent studies art at the Antwerp Academy and then he moves to Paris, lives with Theo and studies at Cormon's studio. He sees the work of the Impressionists and Neo-Impressionists, and befriends several of them. Theo becomes ill.

'87 The Impressionists' palette influences Vincent greatly. He collects Japanese prints and paints in Paris and Asnières. He has a brief affair with Agostina Segatori and exhibits with Gauguin and Bernard in her café. During his two years in Paris, he paints more than 200 pictures.

'88 In February, Vincent moves to Arles in the south of France. He visits Les Saintes-Maries de la Mer in June. Following his dream of having an artists' colony, he takes up residence at the Yellow House. In October, Gauguin joins him, but their relationship deteriorates and Vincent mutilates his ear. Gauguin leaves for Paris.

'89 After spending time in Arles hospital, Vincent becomes a voluntary patient in a mental asylum in Saint-Rémy. Paul Signac visits him. Theo marries Johanna Bonger on 17 April.

1890s

'90 On 31 January, Vincent Willem is born to Theo and Johanna. Albert Aurier writes a glowing article about Vincent's art. Vincent leaves the asylum in May and moves to Auvers-sur-Oise, not far from Paris, where Pissarro has recommended that Dr Paul Gachet cares for him. On 27 July, Vincent shoots himself and dies two days later at the age of 37.

'91 On 25 January, Theo dies.

FURTHER INFORMATION

The Letters of Vincent Van Gogh, Vincent van Gogh (Author), Ronald de Leeuw (Editor), Arnold Pomerans (Translator), Penguin Classics, 1997.
Japanese Prints: The Collection of Vincent van Gogh, Axel Rüger (Foreword), Marije Vellekoop (Foreword), Thames and Hudson Ltd, 2018.
Van Gogh, Steven Naifeh and Gregory White Smith, Profile Books, 2013.
Van Gogh: Complete Works, Rainer Metzger, TASCHEN, 2012.
Van Gogh: a Retrospective, Susan Alyson Stein, Hugh Lauter Levin Associates, 1986.
Van Gogh's Ear: The True Story, Bernadette Murphy, Vintage, 2017.
The Yellow House: Van Gogh, Gauguin, and Nine Turbulent Weeks in Arles, Martin Gayford, Penguin, 2007.

The Van Gogh Museum in Amsterdam, Netherlands, houses the world's largest collection of artworks by Vincent.
The Van Gogh Gallery website is a useful source of information and includes all of Vincent's works: https://www.vangoghgallery.com/
Films:
Loving Vincent, 2017. Directed by Hugh Welchman and Dorota Kobiela
Vincent, 1987. Directed by Paul Cox
Vincent and Theo, 1990. Directed by Robert Altman.

LIST OF ILLUSTRATIONS

Page 3
L'Arlésienne (Madame Ginoux), 1888–9, oil on canvas, 91.4 × 73.7 cm (36 × 29 in), Metropolitan Museum of Art, New York, USA. Bequest of Sam A. Lewisohn, 1951.

Page 6
Self-Portrait, 1889, oil on canvas, 57.79 × 44.5 cm (22¾ × 17½ in), National Gallery of Art, Washington DC, USA. Collection of Mr and Mrs John Hay Whitney.

Pages 8–9
A Watermill in a Woody Landscape, Lodewijk Hendrik Arends, 1854, oil on panel, 20 × 25 cm (7¾ × 9¾ in), Rijksmuseum, Amsterdam, The Netherlands. Everett Collection Inc/ Alamy Stock Photo.

Page 10
Portrait of Theo van Gogh, 1887, oil on cardboard, 19 × 14.1 cm (7½ × 5½ in), Van Gogh Museum, Amsterdam, The Netherlands. Heritage Image Partnership Ltd/ Alamy Stock Photo.

Pages 10–11
Flower Beds in Holland, c.1883, oil on canvas on wood, 48.9 × 66 cm (19¼ × 26 in), National Gallery of Art, Washington DC, USA. Collection of Mr and Mrs Paul Mellon.

Page 12
Letter showing a sketch of *Man Pulling a Harrow*, 1883, pencil, pen and ink, on paper, 20.9 × 26.7 cm (8¼ × 10½in), Van Gogh Museum, Amsterdam, The Netherlands. Bridgeman Images.

Page 13
Letter showing a sketch of *The Potato Eaters*, 1885, pen and ink on paper, 20.7 × 26.4 cm (8 × 10½ in), Van Gogh Museum, Amsterdam, The Netherlands. Wikimedia Commons/ Memory of the Netherlands, From Vincent van Gogh: letters, art, and context of the Van Gogh Museum.

Letter to Paul Gauguin, 1888, 26.4 × 21 cm (10⅓ × 8¼ in), The Morgan Library and Museum, New York, USA. Heritage Partnership Ltd/Alamy Stock Photo.

Pages 14–15
Study for *Deserted – a Foundling*, Frank Holl, 1874, oil on canvas, 55.2 × 76.2 cm (21¾ × 30 in), Private Collection. Photo © The Maas Gallery, London/Bridgeman Images.

Page 15
Prisoners in Newgate Prison Exercise Yard, Gustave Doré, 1869–72, engraving, 23.8 × 19 cm (9⅜ × 7½ in), Private Collection.

Page 16
Calling in the Gleaners, Jules Breton, 1859, oil on canvas, 90 × 176 cm (35½ × 69¼ in), Musée d'Orsay, Paris, France. Bridgeman Images.

Page 17
The Church at Gréville, Jean-François Millet, c.1871–4, oil on canvas, 60 × 73.4 cm (23⅔ × 28⅞ in), Musée d'Orsay, Paris, France. Bridgeman Images.

Page 18
Still Life with Bible, 1885, oil on canvas, 65.7 × 78.5 cm (25⅞ × 31 in), Van Gogh Museum, Amsterdam, The Netherlands. Bridgeman Images.

Page 19
The Harvest, Charles-François Daubigny, 1851, oil on canvas, 135 × 196 cm (53⅛ × 77⅛ in), Musée d'Orsay, Paris, France. Bridgeman Images.

Page 20
Miners' Wives Carrying Sacks of Coal, 1882, watercolour on paper, 32 × 50 cm (12½ × 19⅔ in), Rijksmuseum Kroller-Muller, Otterlo, The Netherlands. Bridgeman Images.

Page 21
Landscape with Woman and Child, 1883, pen and black ink, pencil and wash heightened with white on laid paper, 29.3 × 43.8 cm (11½ × 17⅓ in), Private Collection. Photo © Christie's Images/Bridgeman Images.

Pages 22–3
Road in Etten, 1881, chalk, pencil, pastel, watercolour, pen and brown ink, 39.4 × 57.8 cm (15½ × 22¾ in), Metropolitan Museum of Art, New York, USA. Robert Lehman Collection.

Page 24
The Gleaners, Jean-François Millet, 1857, oil on canvas, 83.5 × 110 cm (32¾ × 43¼ in), Musée d'Orsay, Paris, France. Bridgeman Images.

Page 25
Old Man at the Fireside, 1881, black chalk, reddish brown and grey wash, orange red chalk, opaque watercolour on paper, 56 × 45 cm (22 × 17¾ in), Rijksmuseum Kröller-Müller, Otterlo, The Netherlands.

Page 26
Still Life with Cabbage and Clogs, 1881, oil on paper on panel, 34 × 55 cm (13⅓ × 21⅔ in), The Van Gogh Museum, Amsterdam, The Netherlands.

Fishing Boat on the Beach, Anton Mauve, 1882, oil on canvas, 115 × 172 cm (45¼ × 67¾ in), Gemeentemuseum Den Haag, The Hague, The Netherlands.

Pages 26–7
Nursery on the Schenkweg, 1882, black chalk, graphite, pen, brush and ink, heightened with white on laid paper, 29.6 × 58.5 cm (11⅝ × 23 in), Metropolitan Museum of Art, New York, USA. Bequest of Walter C. Baker, 1971.

Page 27
Young Scheveningen Woman Knitting, Facing Right, 1881, watercolour and gouache on paper, 51 × 35 cm (20 × 13¾ in), Private Collection. Photo © Christie's Images/Bridgeman Images.

Page 28
Sorrow, 1882, pencil, pen and ink, 44.5 × 27 cm (17½ × 10⅔ in), The New Art Gallery, Walsall, UK. Bridgeman Images.

Page 29
Road Behind the Parsonage Garden in Nuenen, 1884, pencil, pen and brush in brown ink, 39.3 × 53.8 cm (15½ × 21⅕ in), Rijksmuseum, Amsterdam, The Netherlands. Bridgeman Images.

Pages 30–1
The Vicarage at Nuenen, 1885, oil on canvas, 33.2 × 43 cm (13 × 17 in), Van Gogh Museum, Amsterdam, The Netherlands.

Page 31
The Parsonage Garden at Nuenen in Winter, 1884, pen and brown ink, white heightening on paper, 51.5 × 38 cm (20¼ × 15 in), Museum of Fine Arts, Budapest, Hungary. Archivart/Alamy Stock Photo.

Page 32
Weaver, 1884, oil on canvas, 62.5 × 84.4 cm (24⅝ × 33¼ in), Museum of Fine Arts, Boston, USA. AKG Images/ MPortfolio/ Electa.

Page 33
Congregation Leaving the Reformed Church in Nuenen, 1884–5, oil on canvas, 41.5 × 32.2 cm (16⅓ × 12⅔ in), Van Gogh Museum, Amsterdam, The Netherlands. Alamy Stock Photo.

Pages 34–5
The Potato Eaters, 1885, oil on canvas, 82 × 114 cm (32¼ × 44⅞ in), Van Gogh Museum, Amsterdam, The Netherlands. Bridgeman Images.

Page 35
Head of a Woman, 1885, oil on canvas, 42.7 × 33.5 cm (16¾ × 13⅕ in), Van Gogh Museum, Amsterdam, The Netherlands. Bridgeman Images.

Page 36
Houses Seen from the Back, 1885–6, oil on canvas, 43.7 × 33.7 cm (17⅕ × 13¼ in), Van Gogh Museum, Amsterdam, The Netherlands. FineArt/Alamy Stock Photo.

Page 37
Portrait of an Old Man, 1885, oil on canvas, 44.4 × 33.7 cm (17½ × 13¼ in), Van Gogh Museum, Amsterdam, The Netherlands.

Granger Historical Picture Archive/ Alamy Stock Photo.

Pages 38–9
View of Paris, 1886, oil on canvas, 53.9 × 72.8 cm (21¼ × 28⅔ in), Van Gogh Museum, Amsterdam, The Netherlands. The Artchives/ Alamy Stock Photo.

Page 40
The Tavern in Montmartre, 1886, oil on canvas, 50 × 64.5 cm (19⅔ × 25⅓ in), Musée d'Orsay, Paris, France. Peter Horree/Alamy Stock Photo.

Page 41
Shoes, 1886, oil on canvas, 38.1 × 45.3 cm (15 × 17¾ in), Van Gogh Museum, Amsterdam, The Netherlands. Bridgeman Images.

Page 42
Vincent van Gogh, John Peter Russell, 1886, oil on canvas, 60.1 × 45.6 cm (23⅔ × 18 in), Van Gogh Museum, Amsterdam, The Netherlands. World History Archive/Alamy Stock Photo.

Page 43
Agostina Segatori Sitting in the Café du Tambourin, 1887, oil on canvas, 55.5 × 47 cm (21¾ × 18½ in), Van Gogh Museum, Amsterdam, The Netherlands. Bridgeman Images.

Page 44
Père Tanguy, 1887–8, oil on canvas, 92 × 75 cm (36¼ × 29½ in), Musée Rodin, Paris, France. Peter Willi/Bridgeman Images.

Page 45
The Hill of Montmartre, 1886, oil on canvas, 36 × 61 cm (14⅛ × 24 in), Rijksmuseum Kröller-Müller, Otterlo, The Netherlands. PvE/ Alamy Stock Photo.

Page 46
A Sunday Afternoon on the Island of La Grande Jatte, Georges Seurat, 1884–6, oil on canvas, 207.5 × 308.1 cm (81¾ × 121¼ in), The Art Institute of Chicago, Illinois, USA. Helen Birch Bartlett Memorial Collection.

Woman Bathing in a Shallow Tub, Edgar Degas, 1885, charcoal and

pastel on light green wove paper laid on silk bolting, 81.3 × 56.2 cm (32 × 22⅛ in), Metropolitan Museum of Art, New York, USA. H.O. Havemeyer Collection, Bequest of Mrs H.O. Havemeyer, 1929.

Page 47
In the Dining Room, Berthe Morisot, 1886, oil on canvas, 61.3 × 50 cm (24⅛ × 19¾ in), National Gallery of Art, Washington DC, USA. Chester Dale Collection.

Page 48
The Sagami River, from the series *Thirty-Six Views of Mount Fuji*, Utagawa (Andō) Hiroshige, 1852, woodblock print, 35.8 × 24.7 cm (14⅛ × 9¾ in), Boston Museum of Fine Arts, Massachusetts, USA. William Sturgess Bigelow Collection. Pictures from History/ Bridgeman Images.

Courtesan (after Keisai Eisen), 1887, oil on canvas, 100.7 × 60.7 cm (39⅔ × 23¾ in), Van Gogh Museum, Amsterdam, The Netherlands. Bridgeman Images.

Page 49
Bridge in the Rain (after Hiroshige), 1887, oil on canvas, 73.3 × 53.8 cm (28⅞ × 21⅛ in), Van Gogh Museum, Amsterdam, The Netherlands. Bridgeman Images.

Sudden Shower over Shin-Ōhashi Bridge and Atake, Utagawa (Andō) Hiroshige, 1857, woodblock print, approximately 37 × 25 cm (14½ × 9¾ in), Private Collection. Photo © GraphicaArtis/Bridgeman Images.

Page 50
Flowers in a Blue Vase, Adolphe Monticelli, 1879–83, oil on wood, 67.3 × 48.9 cm (26½ × 19¼ in), Metropolitan Museum of Art, New York, USA. Gift of Mr and Mrs Werner E. Josten, 1956.

Sunflowers, Roses and other Flowers in a Bowl, 1886, oil on canvas, 50 × 61 cm (19⅔ × 24 in), Stadtische Kunsthalle, Mannheim, Germany. Bridgeman Images.

Page 51
The Restaurant de la Sirène at Asnières, 1887, oil on canvas, 54.5

× 65.5 cm (21½ × 25¾ in), Musée d'Orsay, Paris, France. Bridgeman Images.

Pages 52–3
Montmartre: Behind the Moulin de la Galette, 1887, oil on canvas, 81 × 100 cm (31⅞ × 39⅓ in), Van Gogh Museum, Amsterdam, The Netherlands. The Picture Art Collection/Alamy Stock Photo.

Page 53
Two Cut Sunflowers, 1887, oil on canvas, 43.2 × 61 cm (17 × 24 in), Metropolitan Museum of Art, New York, USA. Rogers Fund, 1949.

Page 54
Bridge at Arles (Pont de Langlois), 1888, oil on canvas, 54 × 65 cm (21½ × 25½ in), Rijksmuseum Kröller-Müller, Otterlo, The Netherlands. Peter Barritt/Alamy Stock Photo.

Page 56
Fishing Boats on the Beach at Les Saintes-Maries de la Mer, 1888, pen and ink, watercolour and gouache on paper, 40.4 × 55.5 cm (17½ × 21⅞ in), State Hermitage Museum, St Petersburg, Russia. Bridgeman Images.

Page 57
The Harvest, 1888, oil on canvas, 73.4 × 91.8 cm (28⅞ × 36⅛ in), Van Gogh Museum, Amsterdam, The Netherlands. Granger Historical Picture Archive/Alamy Stock Photo.

Seascape near Les Saintes-Maries de la Mer, 1888, oil on canvas, 50.5 × 64.3 cm (19⅞ × 25⅓ in), Van Gogh Museum, Amsterdam, The Netherlands. Granger Historical Picture Archive/Alamy Stock Photo.

Pages 58–9
The Yellow House (The Street), 1888, oil on canvas, 72 × 91.5 cm (28⅓ × 36 in), Van Gogh Museum, Amsterdam, The Netherlands. Art Library/Alamy Stock Photo.

Page 59
Sower with Setting Sun, 1888, oil on canvas, 73 × 92 cm (28¾ × 36¼ in), Bührle Foundation, Zürich, Switzerland. Granger Historical Picture Archive/Alamy Stock Photo.

INDEX